Yosemite Once Removed

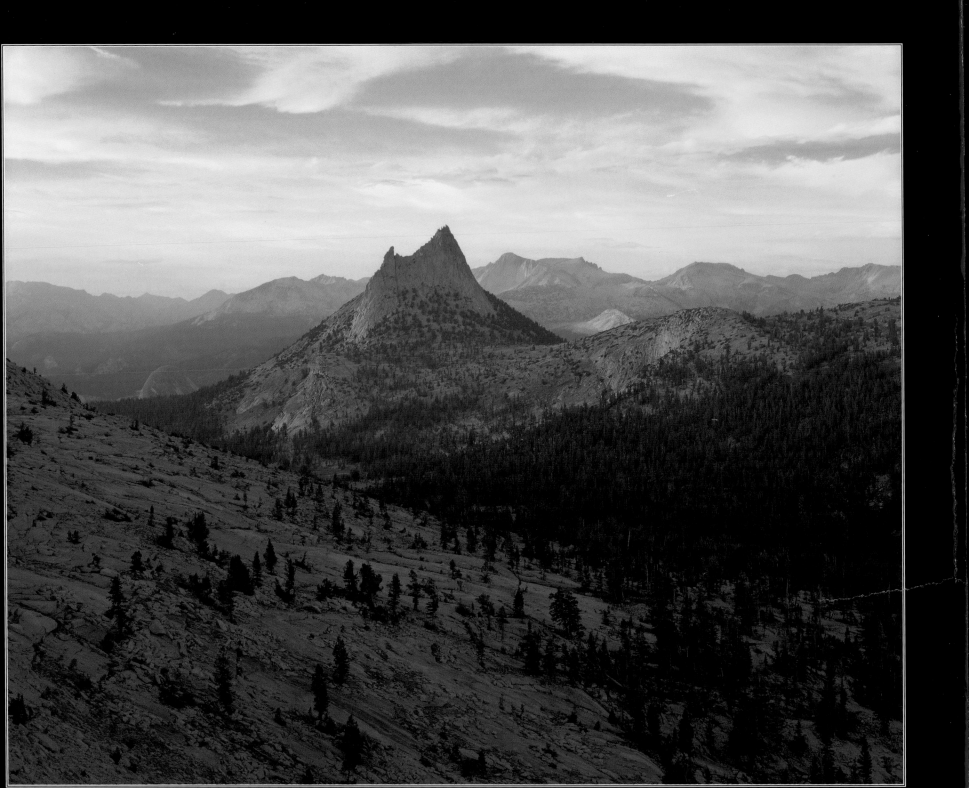

Yosemite Once Removed

PORTRAITS OF THE BACKCOUNTRY

Photographs by CLAUDE FIDDLER

with essays by Steve Roper, Nancy Fiddler, Anne Macquarie, John Hart, and Doug Robinson

YOSEMITE ASSOCIATION
YOSEMITE NATIONAL PARK, CALIFORNIA

CATHEDRAL PEAK FROM COLUMBIA FINGER

For my daughter, Laurel.
I hope our walk through life
is a long and happy one.

Publication of this book was made possible by a generous grant from the

William J. Shupper Family Foundation.

Yosemite Association

Post Office Box 230

El Portal, CA 95318

The Yosemite Association initiates and supports interpretive, educational, research, scientific,

and environmental programs in Yosemite National Park, in cooperation with the National Park Service.

Authorized by Congress, the Association provides services and direct financial support in order

to promote park stewardship and enrich the visitor experience.

To learn more about our activities and other publications, or for information about membership,

please write to the address above or call (209) 379-2646. Our web site address is: www.yosemite.org

Printed in Singapore.

ISBN 1-930238-05-3

One granite ridge
A tree would be enough
Or even a rock, a small creek,
A bark shred in a pool.
Hill beyond hill, folded and twisted
Tough trees crammed
In thin stone fractures
A huge moon on it all, is too much.
The mind wanders. A million
Summers, night air still and the rocks
Warm. Sky over endless mountains.
All the junk that goes with being human
Drops away, hard rock wavers
Even the heavy present seems to fail
This bubble of a heart.
Words and books
Like a small creek off a high ledge
Gone in the dry air.

A clear, attentive mind
Has no meaning but that
Which sees it truly seen.
No one loves rock, yet we are here.
Night chills. A flick
In the moonlight
Slips into Juniper shadow:
Back there unseen
Cold proud eyes
Of Cougar or Coyote
Watch me rise and go.

PIUTE CREEK BY GARY SNYDER

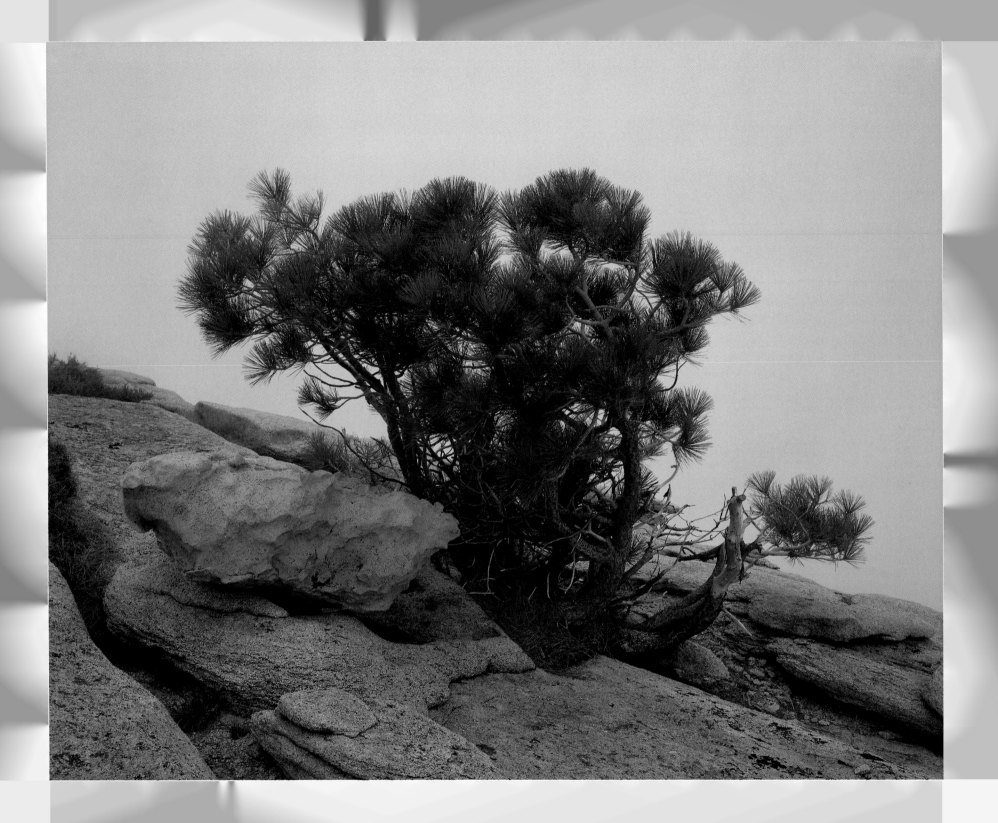

Contents

JEFFREY PINE,
UPPER TENAYA CANYON

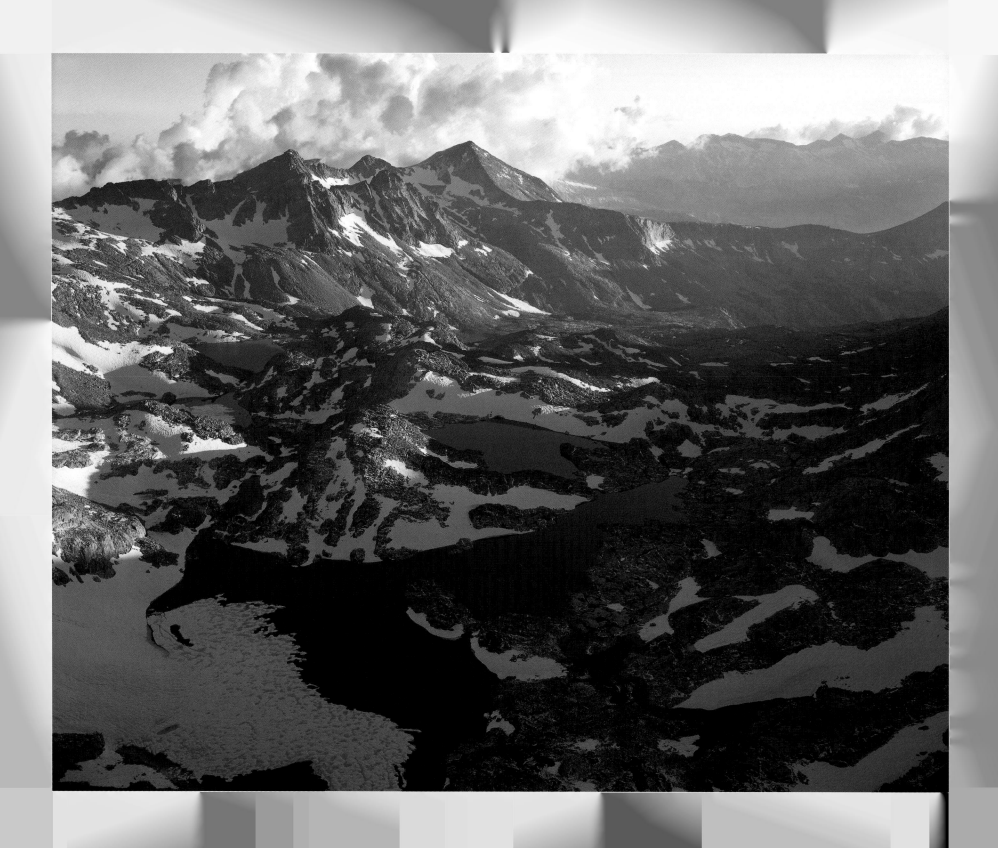

Foreword

\mathscr{I}f I have had a second home, it is the high country of Yosemite. I have often wondered if my life will ever again be as sensually rich as it was in my twenties when I hiked about 1,500 miles there, always with a backpack, usually carrying my view camera outfit, and typically in the company of my most beloved friends. The majority of my mountain mileage was put on in the service of backcountry research for the park, but it would never have happened were it not for Yosemite's sacredness.

I was introduced to the Sierra while still a baby, and later learned from *Gentle Wilderness: The Sierra Nevada* (Richard Kauffman's book of photographs, with John Muir's text and Dave Brower's editing and design) that a person could conceivably make a living in the pursuit of beauty with a camera. It was years before I discovered that Mr. Kauffman had earned his paycheck in the lithography business, not with his pictures, but by then it was too late. I was a landscape photographer committed to the alchemy of turning images of great places into gold.

For our civilization, Yosemite's wildlands are most important for their capacity to provide perspective on ourselves and what we are doing to the Earth. I find it unlikely that anyone who has never spent a good month walking through a reasonably hospitable wild place, sleeping on the ground, being immersed in its reality, could ever really understand that nature is not some kind of side show—a mere backdrop for human kind. In fact, it is we who are the amusement, albeit one very fascinating to ourselves.

Nature is larger than one would guess, not having seen it. And broader. And a whole lot older. We owe it more than just respect, for we really have come from it, and we really are a part of it. To respect it has increasingly come to mean finding ways to leave it alone in the face of our own demand for its resources. The burdens imposed by our own excesses even cause us to drive entire species to extinction. Such wanton destruction strikes me as criminality next to none.

Claude Fiddler and I both know firsthand a lot about the Sierra Nevada, and both of us try our best to respect that which created us, in every aspect of our lives. We can only hope that the fruits of our labors in photography will provide moving testimony of the need for our civilization to exhibit sufficient respect for nature, that her works will remain perpetually intact.

JOSEPH HOLMES

9

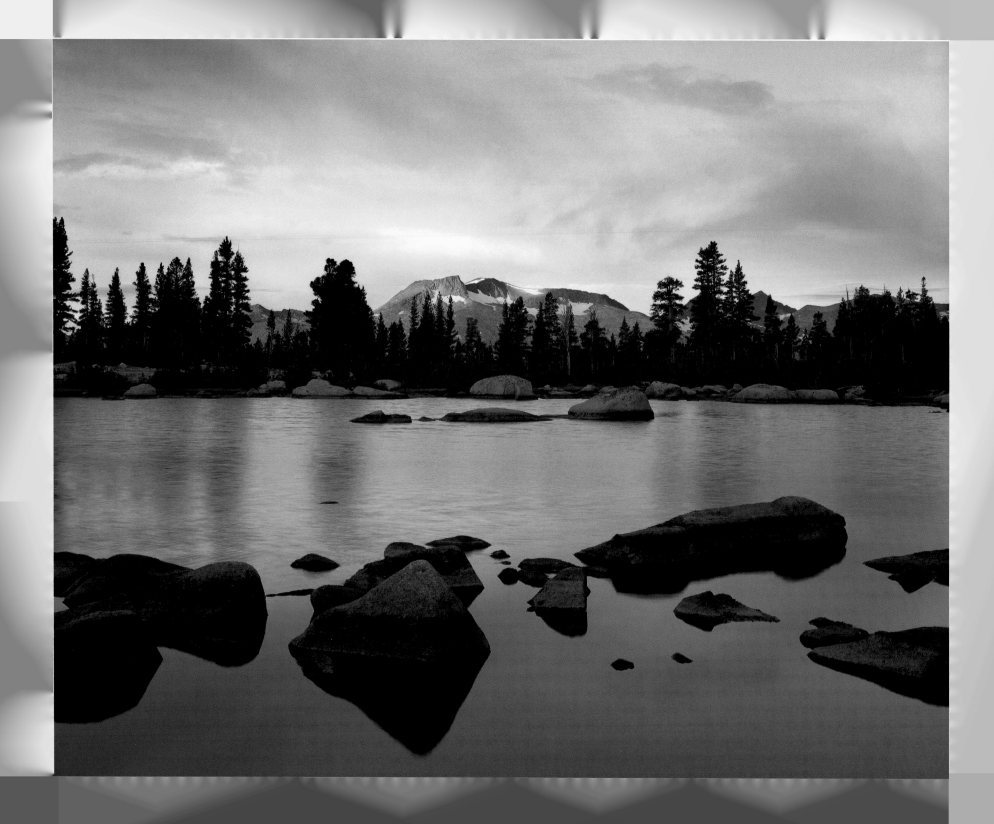

\mathcal{M}y first utterance wasn't "momma" but rather "Yosemite." So it seems now, when so much of my life has revolved around that magical place. Surely it was the first "foreign" term I memorized.

An Introduction to Yosemite's Wilderness

Thanks to childhood trips to Yosemite Valley, I quickly associated the word with cliffs and waterfalls, and to this day, whenever I hear "Yosemite," I see El Capitan, Half Dome, and Bridalveil Fall. I am hardly alone in thinking that "Yosemite" equals sheer granite and free-falling water. But Yosemite Valley, unique as it is, occupies only seven square miles. Yosemite National Park contains 1,200 square miles. What about that other Yosemite, thirty miles wide and forty high? Why does this huge backcountry deserve national park status? This rhetorical question forms the theme of this book, and

BY STEVE ROPER

SUNRISE OVER
TRIPLE DIVIDE PEAK

Claude Fiddler's photographs and the various essays will take you far above crowded Yosemite Valley. That remarkable place, visited by queens and presidents, praised by Ralph Waldo Emerson, Horace Greeley, Ansel Adams, and hundreds of lesser luminaries, will not often be mentioned again. This book illuminates the places the queens and presidents never see.

The mystery begins not far above the valley floor, beyond the icy streams and rivers that tumble into it from unimaginable places. High above, mostly hidden from roads, lie sculpted peaks, pint-sized Half Domes, U-shaped canyons that make the letter "V" feel inferior, acres of glacial polish, foaming creeks, trout to brag about, never-logged forests of red fir, and the finest gathering of granitic domes on earth. Amid this splendor nestle, by my hasty map count, 2,150 lakes and seasonal tarns. Remarkably, only half a dozen of these—Siesta, Tenaya, and a cluster of tarns near Tioga Pass—can be seen from a car.

What makes Yosemite's backcountry different from other parts of the Range of Light? Don't all Sierra peaks, lakes, and canyons look about the same? The answer is a qualified no, and I will argue that the northern High Sierra—basically Yosemite National Park—is unique.

I've always thought that the southern Sierra is more austere than the northern, with vast areas of tundra and talus. Many of the lakes are rockbound and raw. The peaks rise with great relief, and this ruggedness and the numerous east-west sub-ranges make cross-country travel arduous, as well as diminishing long-distance views except from the highest peaks. Few lush forests lie in the interior of this part of the range. Granite rules, as it does throughout the chain, but the rock is often shattered, not sculpted as it is in Yosemite. I love this region.

Why does this huge backcountry deserve national park status?

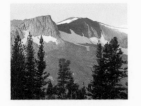

Yosemite is the Sierra's preeminent zone of sculpted granite.

Farther north, the central High Sierra is gentler. But here, too, the spurs shooting west from the main crest make for difficult continuous travel, and above timberline lie great amounts of talus. If the peaks have become more sculpted, many still look as if they had been hit by cruise missiles. I love this region, also.

Much of my allegiance, however, belongs to Yosemite, the Sierra's preeminent zone of sculpted granite. Whoever coined the term "gentle wilderness" for the High Sierra must have been thinking of Yosemite, for this northern part of the range is by no means as craggy as its southern counterparts. Most of the valleys are forested, and lakes nestle amid meadows. Talus, though hardly absent, rarely gets in the hiker's way. Views are extensive because of the less jagged terrain, and cross-country travel is relatively easy.

In this landscape, evidence of former glaciation abounds, much more so than in the southern Sierra. Great U-shaped canyons dominate the countryside, and glacial erratics and polish pop up everywhere. This carved Yosemite high country is indeed a marvelous place, and if this book helps you get up there, onto the trails, onto the burnished slabs, to delicate lakeshores, and up to whitebark pines at timberline, it will greatly please all of us who had a hand in this project.

Many of the soldiers, trappers, artists, surveyors, miners, and charlatans who came west during the nineteenth century wrote about their adventures. The original inhabitants didn't and thus we know little. It is known that Indians had lived in and around Yosemite Valley for perhaps 2,000 years or more. But when the Spanish arrived in central California around 1800, they brought smallpox, and many natives died or fled. A remnant tribe, relatively peaceful and never numbering more than a few hundred, lived within Yosemite Valley during the early nineteenth century. This

13

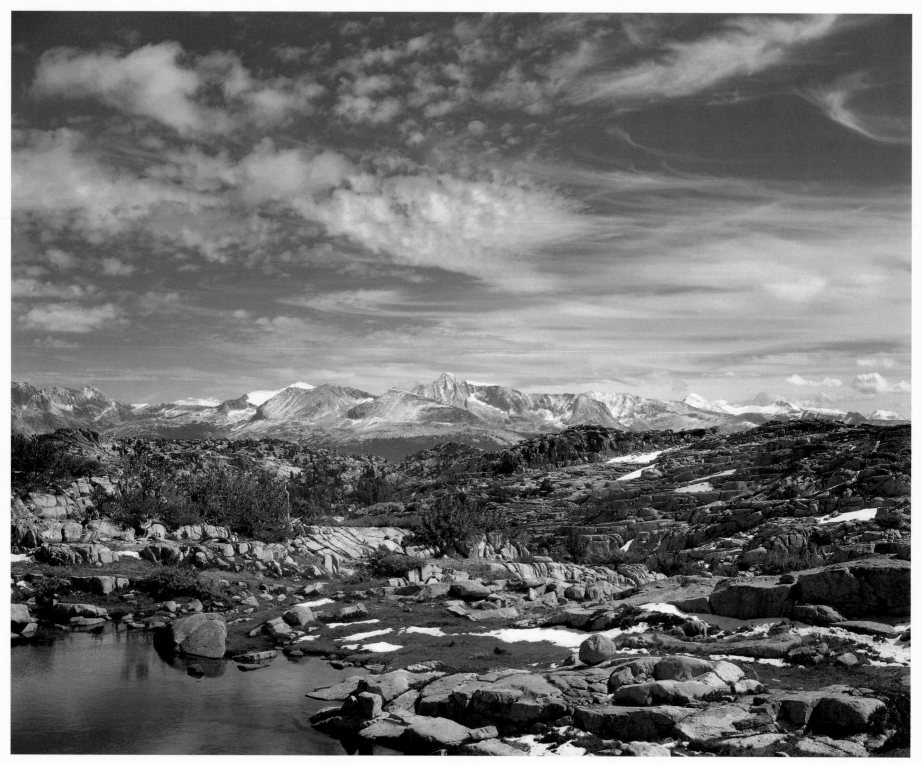

MOUNT CONNESS FROM REGISTER CREEK

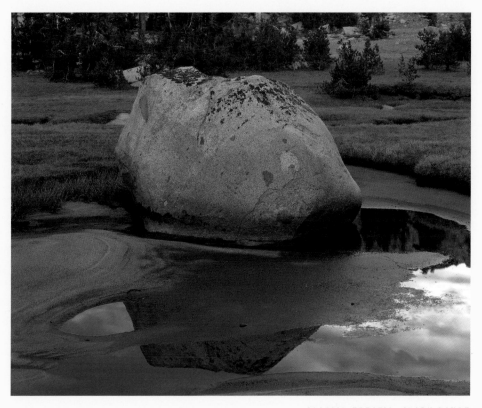

GLACIAL ERRATIC, CLARK RANGE

These two photographs from
the north and south
boundary regions of Yosemite
were taken in places of perfect
isolation. That is to say I felt
completely and perfectly
surrounded by wilderness.

C.F.

One can still find obsidian chips here and there in this region.

must have been Nirvana, with a near-perfect climate and game in abundance. We know also that during the summer months some of the Indians ascended into the high country, crossed the crest at present-day Mono Pass, and dropped into the Great Basin for trading purposes. One can still find obsidian chips here and there in this region, as well as entire arrowheads, sometimes far above timberline.

The first non-natives to see what is now called Yosemite National Park neglected their diaries as they mounted the eastern precipice of the High Sierra. Mountain man Joseph Walker and a band of several dozen trappers had left the Great Salt Lake a few months earlier and now faced the last barrier before reaching the Mexican holding called California. The high range, with its thin air, sparse game, howling winds, retina-damaging sunlight, and late October snowstorms—all coming immediately after the demanding trek across the Great Basin—could kill, and thus must be traversed without a backward look, as if demons pursued.

When Walker and his band stumbled through the Yosemite backcountry in the autumn of 1833, on the first recorded traverse of the central Sierra Nevada, the men had little to say about the austere mountains. Starving and exhausted, they had but one thought: break free of the cold heights and find game lower down. The only notable sights, wrote expedition diarist Zenas Leonard, were two they encountered briefly, lower down in the western foothills: a great chasm with waterfalls and, a few days later, red-barked trees with trunks twenty-five feet across. The party had "discovered" Yosemite Valley and the giant sequoias.

No non-natives visited what is now Yosemite for nearly twenty years, but in 1851 vigilantes (using the dignified militia name "Mariposa Battalion") pursued Indians into their age-old sanctuary, Yosemite Valley. Tensions had arisen between gold rush miners and the natives, and the resulting clash of cultures had, as we all know, a tragic

conclusion. The Indians escaped on this particular occasion, but the same self-proclaimed soldiers hounded the natives into the high country and beyond a few months later, and that was essentially the end of the Yosemite tribe. This is a warped chapter of the American experience—something to be remembered as long as the rivers shall flow.

With the Indians gone, the great granite gorge became locally famous. The first tourists arrived in 1855—forty-two of them arrived that year!

The California Geological Survey had been established in 1860, ten years after statehood, but not until three years later did the group get around to looking at the High Sierra. In late June 1863 Josiah Whitney, director of the survey, and two competent lieutenants, William Brewer and Charles Hoffmann, spent eight days in Yosemite Valley, mapping and marveling. Then the three men, accompanied by a packer and a few mules, climbed northward out of the valley toward little-known territory. On the 24th they ascended a prominent peak quickly dubbed Mount Hoffmann in honor of the group's cartographer. This straightforward climb marks the first verified ascent of a major High Sierra peak.

"Perhaps over fifty peaks are in sight which are over twelve thousand feet," wrote Brewer, "the highest rising over thirteen thousand feet. Many of these are mere pinnacles of granite, streaked with snow, abounding in enormous precipices. The scene has none of the picturesque beauty of the Swiss Alps, but it is sublimely grand—its desolation is its great feature. The scene is one to be remembered for a lifetime."

Certain peaks call out to me, regardless of their height or appearance. Mount Hoffmann won't win a beauty contest, but I've stood atop it seven times now, with more to come. Even as a kid I knew it had been the first High Sierra peak to be climbed, and in 1955, my first time on it, I tried to imagine those three explorers

This was the first verified ascent of a major High Sierra peak.

clustered on the summit, awed by the view. At what point, I wondered, did they name the peak for the cartographer? Right there on top? Did Hoffmann modestly object? Was he secretly thrilled? Did he wonder if his friends were saving higher, prettier peaks for themselves?

A few days later the trio set up camp in what is now a jewel of Yosemite, Tuolumne Meadows. This meadowland—two miles long and half a mile wide—must have struck the men as Paradise. The Tuolumne River snaked through the meadow in lazy curves, yet it was hardly a benign waterway. An enormous volume of deep, icy water surged toward the ocean with hardly a ripple, and one didn't cross it in June without peril.

One morning Brewer and Hoffmann climbed a massive peak on the main Sierra crest, six miles east. So impressed were they with the view that Brewer persuaded Whitney to climb it with him the following day. When they reached the top, Whitney, according to Brewer's journal, "thought the view the grandest he had ever beheld, although he has seen nearly the whole of Europe." With two ascents in two days, instantly-named Mount Dana had become a desirable objective. And it remains so: it is by far the most popular crest peak in Yosemite.

Whitney soon departed for the lowlands, but Brewer and Hoffmann, entranced with the high peaks surrounding them, set off to the south, following the Tuolumne River toward a looming mountain they had spied from Dana. Since they had christened Dana in honor of the most prominent American geologist of that era, their next goal became Mount Lyell, named after the most eminent British geologist of the time. Although the upper few hundred feet of the huge mass proved too difficult for them, the two men explored a vast new chunk of territory. They were, in Brewer's words, "at least sixty miles from civilization on either side, among the grandest chain of mountains in the United States."

Brewer called the Sierra "the grandest chain of mountains in the United States."

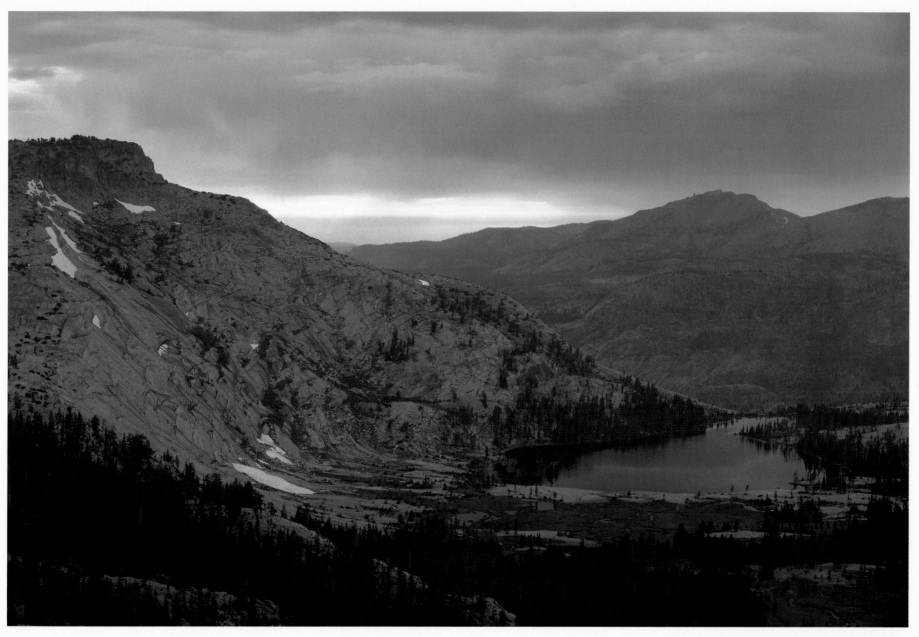

CATHEDRAL LAKE AND MOUNT HOFFMANN

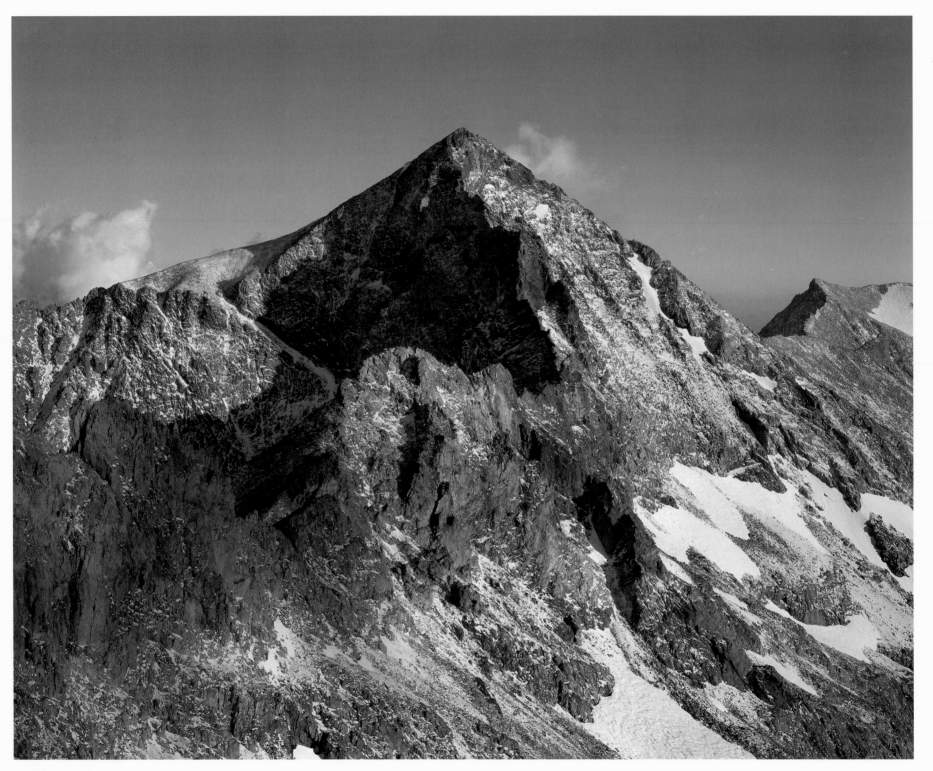

RODGERS PEAK

The Great Sierra Wagon Road became the first major sign of man in the high country.

Even as Brewer and Hoffmann charted the Yosemite high country, frustrated prospectors, too late to be Forty-Niners, wandered through the same district, committed to their hermitic life yet rarely finding anything valuable. The two explorers, in fact, had followed a fairly decent pack trail through the Tuolumne Meadows region, one built by foothill freight companies in order to transport supplies to miners near the Sierra crest and farther east in the Great Basin. (Beautifully weathered buildings and mine shafts can be seen to this day at Mono Pass, Bennettville, and other scattered locations.) "Trains of animals," Brewer wrote, "thus pass nearly every week."

A mere pack trail wasn't good enough for some, as Brewer saw first hand: "A small party exploring for a road camped near us." Twenty years passed before this dream was realized, and the Great Sierra Wagon Road, finished in 1883 (but abandoned the following year when the mining frenzy near Tioga Pass suddenly ceased), became the first major sign of man in the high country.

John Muir was Yosemite's interpreter and champion for more than fifty years, and if the park were to be renamed in his honor, you would hear no squawk from me. Arriving in Yosemite Valley in 1868, at age thirty, the vagabonding Scot found he couldn't leave. He obtained employment initially as a sheepherder and later as a sawyer. The first line of work was fortuitous, for he daily witnessed the damage that "hoofed locusts," as he termed them, could wreak on meadows and hillsides. The second occupation had several advantages over the first. Always a lover of trees, he was to cut only fallen timber, not the grand ponderosa pines and incense cedar surrounding him. And he traded a smelly sheep camp for a tiny but comfortable shack just a few hundred yards from Lower Yosemite Fall, prime real estate then and now.

Muir gazed at the higher country whenever possible, and escaped the valley often.

Two years passed, and much though he came to love the valley, Muir gazed at the higher country whenever possible. His day off, Sunday, often found him "climbing... to the top of the walls for views of the mountains in glorious array along the summit of the range." One reason he escaped the valley so often was that it was getting crowded—1,735 people came in 1870, and on one fine day in May fifty of them occupied the valley floor. In one of his rare sour moods Muir called these visitors "a harmless scum collecting in hotel and saloon eddies." In the same letter he wrote that tourists on horseback mounted "to their saddles like overgrown frogs pulling themselves up a streambank" and later traversed the trails "with about as much emotion as the horses they ride upon."

Muir visited the high country for the first time during the summer of 1869, climbing Cathedral Peak, a striking horn of granite with an exposed and difficult upper section. He undoubtedly ascended other virgin peaks around Tuolumne Meadows, but since he was not one to brag about his achievements, his mountaineering exploits are little known. Muir did keep copious notes of the natural scene, and his curiosity was inexhaustible. It must have been during 1869 that he first began thinking about glaciers and glacial valleys.

Whitney and Brewer had informed the citizens of California, via their survey reports, that glaciers no longer existed in the state; they had also put forth the proposition that Yosemite Valley must have been created when its floor dropped thousands of feet as a result of a fault-block cataclysm. Muir's eyes told him a different story, and he was to spend much of the next decade proving the survey wrong. His confidence increased after he found dozens of active Sierra glaciers—not big, spectacular ones, like in the Alps, but nevertheless moving bodies of ice. He then came up with a bold concept: Yosemite Valley had been created not in a sudden jolt but rather in the more usual manner—by erosion. The Merced River, he postulated, had

carved a significant V-shaped canyon (Muir, like everyone of his era, never dreamed that this took tens of millions of years), and monster glaciers later scoured the canyon into its present dramatic form.

Whitney scoffed at this idea, saying, "a more absurd theory was never advanced." Clarence King, another former member of the survey, and a noted Sierra explorer, concurred: "It is to be hoped. . .that the ambitious amateur himself [Muir] may divert his evident enthusiastic love of nature into a channel, if there is one, in which his attainments would save him from hopeless floundering." Muir turned out to be mostly correct, but there's no record that Whitney or King ever acknowledged this.

We now know a fair amount about the glacial record. About a million and a half years ago the Pleistocene Ice Age began, and in Yosemite the Tuolumne Glacier—sixty miles long at times—started sculpting the high country. For several thousand centuries the present site of Tuolumne Meadows lay under 2,000 feet of solid ice. The northern High Sierra a million years ago looked like present-day northern Greenland, with rock horns peeking above the timeless ice cap and dozens of valley glaciers spilling off it. (The southern Sierra also had huge valley glaciers, but ice caps didn't form.)

A warming trend led to the disappearance of these vast ice sheets about 750,000 years ago, but three or four other major episodes of glaciation occurred in the Sierra during the ensuing millennia, and the high country was periodically overrun with ice caps and small valley glaciers. About 20,000 years ago the Sierra again lay smothered by ice, and the glacial polish we see today results from this interlude. Then, 12,000 years ago, every glacier in the Sierra rather abruptly disappeared due to a radical climate change—the floods on the western slope of the range must have been stupendous. Finally, around 1250 the "Little Ice Age" began, and only then did the Sierra's 99 existing glaciers and 398 "glacierets" (permanent snowfields that may or

A million years ago the northern High Sierra looked like present-day northern Greenland.

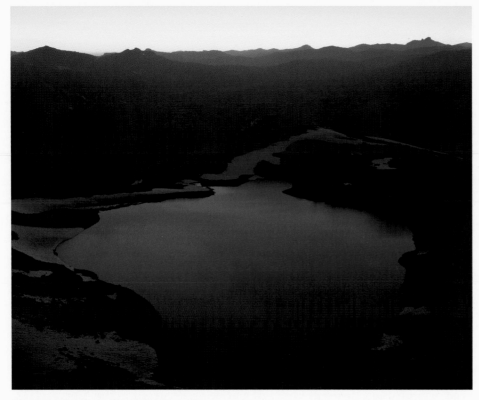

TWILIGHT FROM ABOVE SPILLER LAKE

There are those moments in the

backcountry when my life

is perfect and clear. I was

once asked if I was ever lost

in Yosemite. Never.

C.F.

GLACIAL POLISH, TOWNSLEY LAKE

may not creep downward—few of these have been studied) begin to form. This relatively minor cooling trend ceased around 1900 and the glaciers have diminished since then.

Some scientists predict a cyclic return of major worldwide glaciation in about 18,000 years, but what humans do to their fragile planet in the meantime will obviously affect this scenario. "Seen in geological perspective," Wallace Stegner once wrote, "we are fossils in the making, to be buried and eventually exposed again for the puzzlement of creatures of later eras."

In addition to being a renegade glaciologist and a superb writer, Muir, because of his knowledge of Yosemite, became an excellent "public relations" man. Professors and artists sought him out, and the Scot made sure they not only saw the wonders but learned of the problems the region faced. In 1871 Muir invited the most famous living American writer, Ralph Waldo Emerson, to Yosemite. That Muir appreciated the high country as much as the valley is clear in his witty letter: "I invite you to join me in a month's worship with Nature in the high temples of the great Sierra Crown beyond our holy Yosemite. It will cost you nothing save the time, and very little of that, for you will be mostly in Eternity." Emerson couldn't resist, but because he was frail he visited only Yosemite Valley.

Muir began to reach even wider audiences through his writings. In 1875 he learned that certain groves of giant sequoias, south of Yosemite, were being bought by private citizens, both for logging and for commercial development. Around the same time, Muir saw a flock of 2,000 sheep trampling a similar grove. Alarmed at this and similar abuse elsewhere, Muir wrote an article for a Sacramento newspaper pointing out that sheep were destroying the fragile meadows of the Yosemite high country. (Yosemite Valley itself had been made the equivalent of a state park in 1864, so it was well protected.) This was the beginning of Muir's illustrious career to preserve the wild places of the west.

Muir's illustrious career to preserve the wild places of the west began in Yosemite.

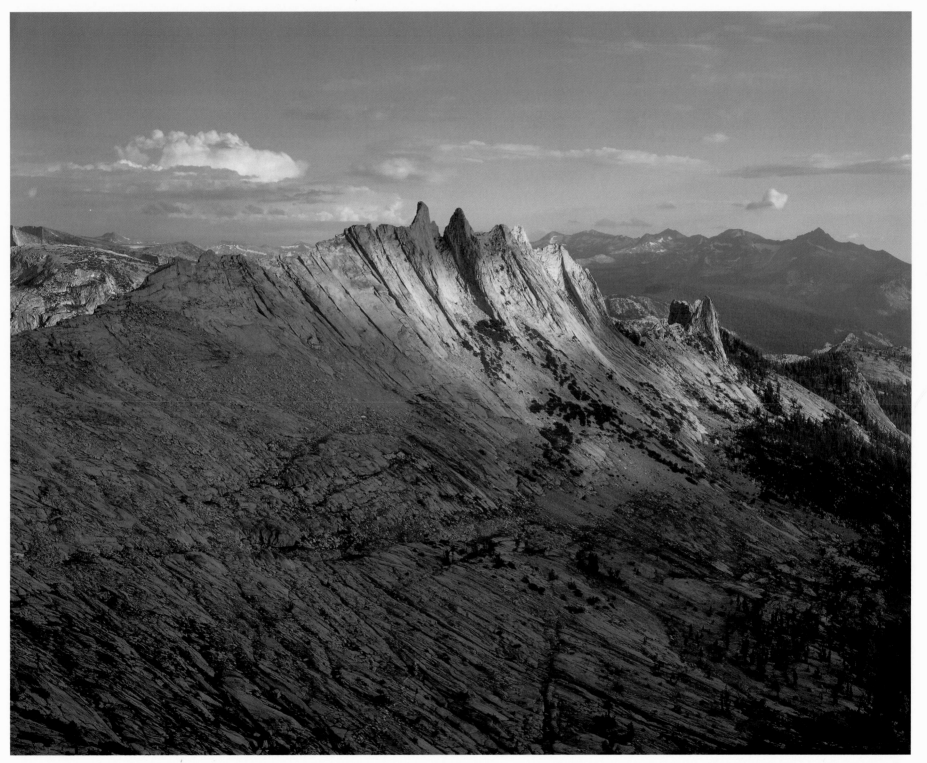

MATTHES CREST FROM ECHO PEAKS

On October 1, 1890, Yosemite National Park became a reality.

Muir and his cohorts had limited success in arousing public sentiment during the 1880s, but at the end of that decade he was instrumental in establishing Yosemite National Park. Some of the impetus for the new preserve came from a most unlikely place. Robert Underwood Johnson, an editor at *Century*, a popular magazine based in New York, decided to do a series of articles on California. He came west during the summer of 1889 and eventually met Muir, who cleverly suggested a trip to Tuolumne Meadows. The persuasive naturalist showed Johnson the beauties of the high country—and some of its less attractive segments, such as trampled meadows and eroded gulches caused by overgrazing.

Muir wrote an eloquent pair of articles for *Century* the following year; meanwhile Johnson used his big-city influence to push for the region's protection. California partisans submitted a bill to Congress on the last day of that year's session, and, incredibly, it passed within hours. On October 1, 1890, Yosemite National Park became a reality.

A paper park, however, does not a real park make. Who would police the sheepherders, miners, lumbermen? The federal government dispatched troops to oversee the administration of the new park, but several cavalry detachments for a 1,630-square-mile reserve were hardly sufficient. Moreover, Congress had ignored two necessities: appropriations and laws with bite.

In 1891 the park's superintendent reported that 90,000 sheep surged around the western and southern boundaries, presumably bleating for the succulent meadows above. "As soon as our backs were turned," he predicted, "the herds would be slipped in and grazed until another patrol came along." But the superintendent had a plan: his men would detain a trespassing shepherd (protection of civil rights being rather lax back then), escort him to the opposite side of the park, and release him. The shepherd

would immediately head back to his flock, but a week would have passed—and the flock would have dispersed all over the landscape, panicked by bears, cougars, and coyotes. The owner of the flock, so the theory went, would get wise and order his shepherd to stay outside the reserve.

Two years later the superintendent reported that "so far this season no willful trespass by the sheepmen has been discovered." The superintendent, accurate in that his patrols hadn't found trespassers, didn't realize that shepherds were simply taking their flocks into even more remote districts. Finally, by the turn of the century, the battle was won. One byproduct of this extensive campaign: army patrols explored and mapped a vast amount of new territory, and their tree blazes are still visible today. In particular, the great, parallel, U-shaped canyons in the northeastern part of the park—Spiller, Matterhorn, and Virginia—were made known to the world.

The high country became even better known after the turn of the century when the Sierra Club, founded by Muir and others in 1892, decided to head for the hills. In July 1901, ninety-six club members gathered in Tuolumne Meadows. Included in this group were Muir, his daughters Wanda and Helen, the noted landscape artist William Keith, and the chief of the United States Biological Survey, C. Hart Merriam. For several weeks the participants climbed peaks, explored, fished, and enjoyed the bracing mountain air. For most of them, it was their first-ever view of the Sierra's timberline country.

During the succeeding decades, Sierra Club members, in groups of about 200 per trip, annually visited the three most accessible areas of the Sierra: Yosemite, Kings Canyon, and the Mount Whitney region. The usual modus operandi was to stay several days at a choice location, move on for a day or two to the next such site, stay a while,

The high country became even better known when the Sierra Club decided to head for the hills.

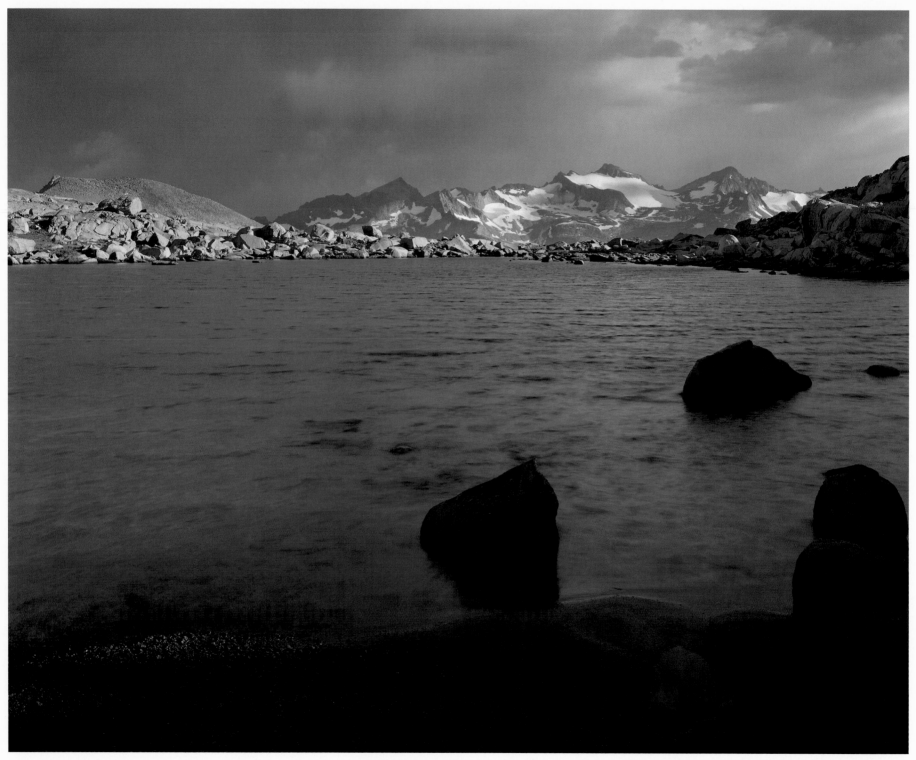

TARN AND MOUNT LYELL

and so on, often making a gigantic loop. (Such "High Trips," as they were called, ceased in the 1960s when club leaders realized that huge groups harmed fragile subalpine locales.)

The 1907 outing was a typical one. The setting chosen for the main base camp was that marvelous blend of forest, rock, meadow, and water: Tuolumne Meadows. The group spent a week at this idyllic site, then began working south across the Cathedral Range toward the headwaters of the Merced River, territory previously unvisited by the club. Strings of pack animals transported the paraphernalia necessary for the self-contained expedition. Huge iron stoves, cooking pots, bedding, and vast amounts of foodstuffs—all had to be balanced carefully onto the mules' backs. Packers, cooks, and their assistants broke camp as soon as possible after breakfast and traveled at a steady, rapid rate in order to have the next camp established by the time the outing participants arrived singly or in small groups.

Following dinner each night, the tired hikers would gather around a gargantuan campfire to enjoy lectures by eminent men of science, yarns spun by aging Civil War veterans, and performances by talented musicians. Group singing and hot drinks capped the evening's entertainment. Then, if one were fortunate, the rising full moon would light the way to a snug sleeping bag.

While most of the 1907 outing members fished, loafed, and enjoyed short hikes in proximity to the long-term camp at Washburn Lake, fifteen intrepid climbers loaded five days' worth of food onto their backs and headed east over virtually uncharted country toward distant Mount Ritter. Their pioneering route crossed Blue Lake Pass, near Harriet Lake, descended remote Bench Canyon to the north fork of the San Joaquin River, and surmounted the steep but lovely shelves and slabs rising toward Ritter. This peak, first climbed by Muir thirty-five years earlier, had been inside

The setting chosen for the club's main base camp was Tuolumne Meadows.

Miners, loggers, and homesteaders forced a realignment of the park boundaries in 1905.

Yosemite until the boundary revisions of two years earlier. In short order all fifteen stood atop the famous peak. Some days later, after the entire group had gathered once again in Tuolumne Meadows, leader Will Colby guided them down the wild gorge of the Tuolumne River and back to civilization. The month-long trip of 1907 was over.

By 1900 the boundaries of the new park were causing problems. Maps being poor back then, the planners of 1890 had simply drawn, in essence, a giant rectangle on the map and declared it the new reserve, ignoring natural boundaries such as ridgelines and rivers. They also inadvertently included much sub-standard scenery on the west and southwest—lowland territory becoming populated by the turn of the century. Miners, loggers, and homesteaders forced a realignment of the boundaries in 1905, and about 430 square miles vanished from the park. Unfortunately, one of the most handsome areas of the High Sierra—the Ritter Range, in the southeast quadrant of the park—was eliminated, thanks to pressure from mining interests. When California ceded the valley to the federal government in 1906, the park, as we know it today, was complete.

In 1915, Congress created the National Park Service and rangers replaced army troops—the modern age had arrived. A person born in 1850, when Yosemite Valley was undiscovered, could, at age sixty-five, drive a Model-T Ford into the sanctuary, camp anywhere for three or four or five months, cut down trees that blocked the view, build gigantic fires, and otherwise enjoy the place. About 20,000 tourists visited the park in 1915.

The valley, of course, was (and will always be) the park's chief attraction, and relatively few people entered the high country. But superior transportation allowed the valley to be reached easily. The first automobile had chugged along the valley floor in

1900; two more appeared the next year. This doubling concerned the superintendent, who thereupon did something that no other official has ever dared try: he banned autos from Yosemite! The ban was lifted twelve years later by the clamor of public opinion—and this naturally caused visitation to soar. Around the same time (1907) a railroad had been constructed from the San Joaquin Valley to El Portal, fifteen miles west of the valley. So by 1920, with the war over, an automobile in every garage, a chicken in every pot, and a railroad close by, about 70,000 persons sought out the park.

Contemplating this population explosion, the park service and the park concessionaires concluded that the reserve should be "developed" to handle all the new visitors, and the 1920s saw this happen to an extreme. It was still possible to leave the park in a semi-pristine condition, but the Roaring Twenties were an era of "progress," and the public, tired of narrow roads and rustic lodgings, lobbied for new facilities. An excellent, paved, all-year highway up the Merced River Canyon opened in 1926. The classy Ahwahnee Hotel was unveiled the next year, and nearly 500,000 people streamed into the park, a hundred-fold increase in a single generation. Soon the valley floor became a village, with stores, gift shops, swimming pools, lodges, hotels, a stable, a small hospital, numerous campgrounds, and tent cities for the many hundreds of employees needed to run this new town.

The high country became more visited also, of course. The rights to the decrepit, privately owned Tioga Pass Road had been purchased in 1915 by a group headed by Stephen Mather, the first director of the new park service, and donated to the park; it was soon turned into a motor route. A new road up Lee Vining Canyon, east of Tioga Pass, meant that a trans-Sierra highway was now a reality.

The park service and the park concessionaires concluded that the reserve should be "developed."

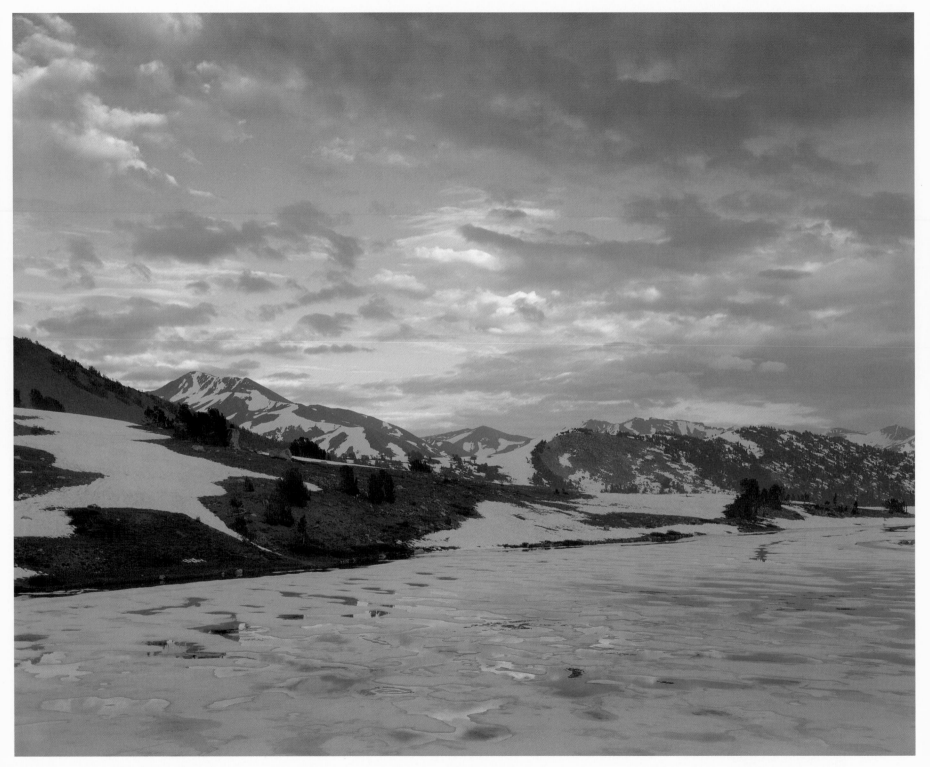

LOOKING SOUTH FROM GRANITE LAKES

In 1924 the park concessionaire began establishing small tent villages in the high country.

In 1924 the park concessionaire began establishing small tent villages in the high country, most of which were far from roads. (The number and location of these camps changed several times over the years; the present circuit of fifty-three miles begins and ends at Tuolumne Meadows, with overnight stops at Glen Aulin, May Lake, Sunrise, Merced Lake, and Vogelsang.) These well-equipped High Sierra Camps—as they became known—allowed hikers to make a week-long circuit of the backcountry without having to carry a heavy pack or possess camping skills. Families, especially, appreciated this money-making gambit of the concessionaire, and several generations of youngsters learned to value the mountains as they strode the fabulous loop.

During the 1930s, thanks to the Great Depression, visitation leveled off and the furious rush to "improve" the park slowed. Except at the construction site of the Badger Pass ski area in 1935—a terrible blight upon the backcountry landscape—the park remained mercifully free of bulldozers and cement mixers.

Into this quiet world came the climbers. Technical gear imported from Europe, combined with advanced belaying methods, meant that the craggy spires known as "cockscombs" south of Tuolumne Meadows could be climbed safely. The newly-formed Sierra Club Rock Climbing Section took full advantage of the opportunity. How I envy pioneers like Jules Eichorn, David Brower, and Glen Dawson! Dozens of dazzling, unclimbed pinnacles and remote peaks beckoned, and these bold lads and others picked them off one by one whenever they weren't establishing even harder routes down in the valley.

Winter mountaineering also became popular among the cognoscenti, and, with Brower the driving force, Mounts Lyell and Clark saw their first winter footsteps. Such grand adventures had a more chilling effect a few years later: with their newfound expertise, many of the club's best climbers served in the army's famed 10th Mountain

The Tioga Pass Road re-opened as a high-speed highway in the summer of 1959.

Division, a unit that saw much action in northern Italy at the close of World War II. Sadly, some of the combatants didn't return. Another, more positive effect was that the nylon ropes, angle pitons, and aluminum carabiners developed for the war effort by Californians and others made possible the beginning of the Golden Age of Yosemite Valley climbing.

Roadbuilders improved segments of the Tioga Pass Road in 1940, but a twenty-one-mile stretch, from the White Wolf turnoff to Cathedral Creek, remained narrow, steep, and hairpin-riddled; this section discouraged timid travelers from leaving the safe confines of the valley and venturing into the high country. Still, weekend traffic jams on this stretch were legendary, and I well remember long Friday evenings (and Sunday afternoons) in the late 1950s. Steaming cars with their hoods up lined the road's edges, leaving just enough room to squeeze past. Although park officials warned against trailer use, a few naive tourists dragged them along behind wheezing old clunkers, going ten miles an hour and pulling a train of thirty or forty not-so-patient autos behind them. I also remember noticing scarred roadside trees and wishing I could see, just once, an especially slow trailer clip one.

Chambers of commerce on both sides of the range lobbied heavily for that particular section of road to be improved. They prevailed, and a high-speed highway opened in the summer of 1959—but at a severe price. Where the old road had followed the contours of the land, the new one was marred by huge roadcuts and dynamited granite slabs. The new road between Olmsted Point and Tenaya Lake traversed a gigantic slab of granite that had been dynamited into submission; the scar extended for hundreds of yards and could be seen from miles away. A chagrined David Brower, by then the executive director of the Sierra Club, wrote, "Please let us allow no one to forget what

the experts killed there, needlessly, in large measure because we who knew they were wrong held our tongues." Ansel Adams felt likewise, having watched firsthand as the road was "blasted through the mood and heart of a priceless treasure. . .Only another glacier age can heal the scars of Tenaya."

The drive had been shortened by a full thirty minutes, however, and traffic flowed smoothly and safely. Getting to the high country from the valley was now a trivial ninety-minute jaunt, and trailers and RVs—just then coming into vogue—hummed along at the speed limit. (Those interested in seeing the old road can do so on two preserved sections, the first near Yosemite Creek Campground and the other the short and lovely stretch to the May Lake trailhead. Try to imagine these now-deserted roads with heavy traffic inching along!)

Backcountry use greatly increased in the 1960s and 1970s. The new road helped; prosperity reigned; and many of the emerging counterculture generation had an urge to "return to nature." In his 1965 novel, *Desolation Angels,* Jack Kerouac wrote that ten years earlier he and poet Gary Snyder had predicted "a rucksack revolution" in which "millions of Dharma bums" would head to the high country to "meditate and ignore society." Tens of thousands of middle-class young Americans did just that during the Hippie Era; had the millions arrived we would have a different national park today.

Because of this new influx, park officials instigated a mandatory trail-permit system in the mid-1970s, a "governmental interference" that angered many, including me. I avoided getting permits for a few years and was never confronted by a ranger. Eventually I thought better of this antisocial behavior and, of course, immediately encountered a pleasant ranger who asked to see my permit. Armed with an obvious radio, and, for all I knew, a hidden derringer, she waited politely. Glad I had become a conformist as I flashed my permit, I nevertheless mourned the incursion of police into the mountains.

Because of this new influx, park officials instigated a mandatory trail-permit system.

FALL COLOR NEAR SMEDBERG LAKE

Fall is my favorite time
in the backcountry. The pikas are
haying, and the color is changing.
I sense the mountains shutting
down and getting ready for
winter's solitude.

C.F.

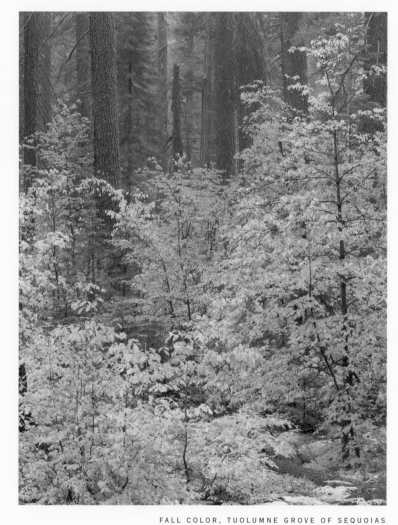

FALL COLOR, TUOLUMNE GROVE OF SEQUOIAS

Popular backcountry campsites near roads, such as the two lovely Cathedral Lakes, became eyesores during the 1970s. Fortunately, as Anne Macquarie notes later in this book, the park service took action, cleaning existing campsites, banning fires above 9,600 feet, limiting the size of groups, and educating the backpacking public by means of eloquent pamphlets. The high country began to recover.

Yosemite's backcountry is in good shape today, as I saw to my delight on several recent trips. One such excursion proved quite remarkable in this regard. I had decided to climb Mammoth Peak, that truly mammoth but not-too-pretty mound of talus four miles south of Tioga Pass. Early October is a fine time to wander through the Sierra, but mornings can be arctic, as I discovered within five steps. Bundled up in anticipation and knowing the sun would peek over Mount Gibbs within the hour, I barely shivered. The Mono Pass Trail, a major thoroughfare to the south, soon evolved into a mere single-track path, even when it traversed fragile meadows, where multiple ruts are always a possibility. Obviously, not many pack animals used this trail: one of the pleasures of Yosemite hiking is that pack trains are rare except on the High Sierra Camp Loop. Boulders in the nearby stream glittered with ice, and when the sun's rays finally hit me I bowed east and rendered a croaky yodel.

During the four-plus miles to elegant Spillway Lake, I saw not a bit of trash, not a single fire ring. When most of this area was closed to camping a few years back, rangers and others went to work and cleaned the place up. Except for the path itself, I could find no evidence that anyone had ever preceded me. Later, heading cross-country up the hill to Bingaman Lake, I expected to find ducks, those annoying man-made piles of stones that once marred so much of the High Sierra. No ducks. No trace of a fisherman's

Pack trains are rare in Yosemite except on the High Sierra Camp Loop.

path. No footprints. Bingaman also looked like no one had ever visited it and it was only three hours from a major road!

I reached the top of Mammoth two hours later, beat from the exertion and dulled by the altitude. A frigid blast from the west almost toppled me, but, since I had never seen this particular view, I lingered. Segments of the Tioga Road, many thousands of feet below, barely interfered with the otherwise primordial landscape. From Tower Peak on the far north boundary to icy Mount Lyell on the south, from wide, wide Matthes Crest on the west to golden Parker Pass, almost touchable to the east, the entire eastern half of the park lay before me. Six hundred square miles of wilderness!

Thrilled and chilled, I returned to the lowlands via Kuna Lake, seeing no footprints, no paths, no campsites for two more hours. And, as I finally dragged my aching carcass into the parking lot, I realized I'd not seen a soul the entire day. For an instant I enjoyed a selfish feeling that the park had been set aside just for me—my private playground.

Will the Yosemite backcountry remain so undefiled? Will travelers a century hence look at Claude Fiddler's photographs and say that nothing has changed? I believe so. If any one thing in this bewildering world we inhabit remains the same generation after generation, it is the wilderness. This, to me, is a highly comforting thought.

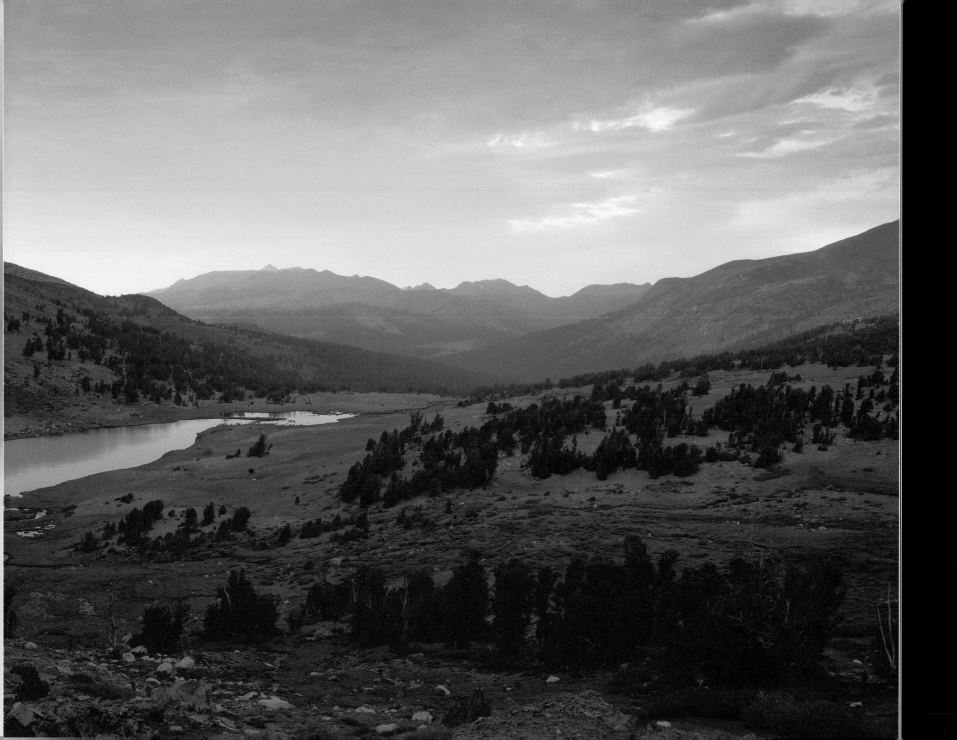

The first time I entered Yosemite National Park

I didn't pass through an official entrance station. I never caught a glimpse of

a famous waterfall or of Half Dome. There were no crowds, for, other than

A View from the East

my traveling companion, I saw not a soul. My first impression of Yosemite

was thus indelibly formed. Twenty years later the significance of this trip

seems enormous to me, but at the time I had no idea that what I was doing

was exceptional in any way. Certainly I did not know that this experience

would change my life forever. My story begins on a long-ago day in early May

in the vicinity of Walker Lake, on the east flank of the High Sierra. Carrying

skis on our backpacks, my friend Tom and I were heading up Bloody Canyon

toward the eastern boundary of Yosemite.

BY NANCY FIDDLER

We were forced to walk for a distance, picking our way through the remaining patches of dirty snow that lay on the forest floor. As we gradually gained elevation, the snow patches gave way to a consistent snow covering, and we donned skis. Excited but nervous, I clicked into my bindings and heaved on my pack.

Ascending the forested lower slopes of Bloody Canyon took all of my attention. Tom, the more experienced skier, led, zigzagging uphill to gain elevation. I trudged along behind in his tracks, blissfully ignorant of what this day, this trip, was all about. The imposing junipers, Jeffrey pines, and red firs mingled with a few leafless aspens to form an open, not unfriendly forest.

Although this particular forest was unfamiliar, it offered a protective haven to an easterner unaccustomed to the vast open spaces of the west. In the short time I had been in the eastern Sierra, I had not gotten used to the landscape, but I felt far more comfortable in this forest of stately trees than I had in the high desert scrub of the Mono Basin that we rapidly were leaving behind.

Growing up in the northeastern United States, I had always taken the presence of trees for granted. The trip west had been a visual education: an onslaught of stark, huge, treeless landscapes that left me overwhelmed. There was nothing friendly or beckoning about these windswept scenes. Driving through the basins and ranges of Nevada, I had found little solace even in the shapely piñons that dotted the mountainsides.

My early morning euphoria soon gave way to curiosity and fatigue. Where were we going? When would we get there? Although a competent skier, I had never skied with a backpack. In fact, I had never been backpacking at all. All my skiing experiences, both alpine and cross-country, had been on well-marked, groomed trails. It was hard work to ski without a trail.

This forest offered a protective haven to an easterner unaccustomed to the vast open spaces of the west.

I encountered landscapes that no art history class could have prepared me for.

In the east, downhill ski areas and cross-country centers alike have swaths cut through the forests to make passage as effortless as possible, and skiing off trail is exceedingly difficult. The woods, as forests are called, are dense and choked with underbrush, and for the most part are not suitable for carefree ski touring.

The borrowed backpack I was using was not a perfect fit and wearied me sooner than I expected. Tom, an old hand at skiing, climbing, and hiking with packs, seemed oblivious to my growing discomfort. Though I had spent many happy times camping while growing up, I now regretted never having been backpacking. My limited hiking experience in New England included a few day trips to the White Mountains, characterized by hours of toiling uphill on a slippery trail through dank, dense woods. The individual peaks I climbed have not stayed in my memory, but I do clearly remember bursting out of the trees onto a rocky summit only to be greeted by a frigid blast of wind. The long-awaited view was duly taken in, and then it was time to leave the heights and begin the leg-burning descent back through the woods.

My family's preferred method of wilderness travel involved canoes. My father, a Minnesota native, had a lot to do with this, and the better part of my sixteenth summer was spent paddling through the lakes and streams of Ontario. The waterways provided easy, open travel through otherwise unnavigable terrain, and gear and provisions for weeks were stowed easily in our canoes, enabling us to take lengthy trips. This was all I knew of overnight wilderness travel.

Now, on my first trip to California, I found myself heading out on a four-day ski tour into the Yosemite hinterlands. The little I knew about the place came from studying slides of Bierstadt paintings in a darkened college classroom in Maine. As Tom and I climbed above timberline that spring morning, I encountered landscapes that no art history class could have prepared me for.

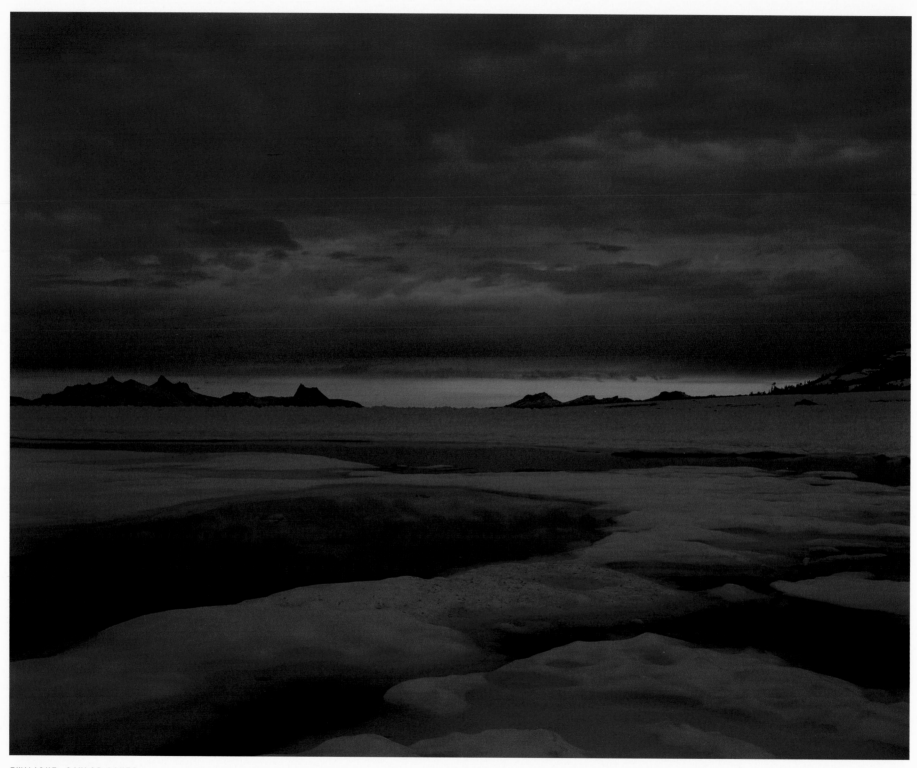

TWILIGHT, GAYLOR LAKES

During our thirty-three days of
skiing the John Muir Trail,
Jim and I felt pretty out there
until we reached the top of
Donohue Pass. Skiing toward
Tuolumne Meadows was
like we were coming home.

C.F.

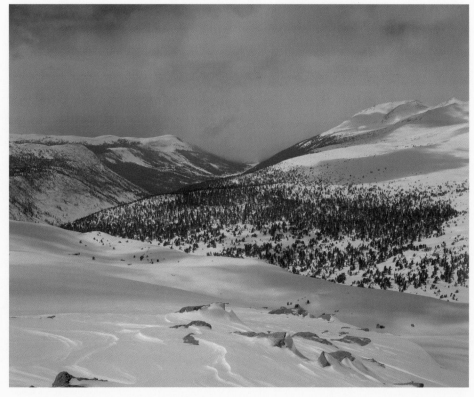

LYELL CANYON

I glanced down the canyon one last time, again amazed by the distance we had covered.

Above treeline at last, I had for the first time that day the feeling of being in a canyon. The gray cliffs of Mount Lewis to the south and the colorful red and gray shoulder of Mount Gibbs to the north formed the walls of Bloody Canyon. Looking back, I was surprised to see how high off the desert floor we had climbed. The frozen surface of Walker Lake lay far below, and beyond, the view stretched past the pale blue water of Mono Lake to the distant ranges of Nevada. The northernmost Mono Craters stood out as well, the row of barren, snow-capped cones lending a surreal quality to the scene. I was struck by the disparity between the backdrop of the arid Mono Basin and the snowy landscape of our ski route.

Up, up we traveled across a brilliant white slope broken only by an occasional whitebark pine. Here and there were outcrops of the same red rock that formed part of the massive canyon walls. I could hear the sound of water gurgling and splashing as the midday sun warmed the snowpack, and we drank greedily from this run-off whenever we could capture it running over sunny, exposed rocks. It was hot, the heat made more intense by reflection in the bowl through which we skied.

Exhausted by the effort, the weight of my pack, and the sun's fierce rays, I was anxious for some sign that we were not far from our destination—Mono Pass. Above Lower Sardine Lake rose a headwall, and I numbly followed Tom, who remained as cheerful as ever, not at all put off by the seemingly impossible stretch ahead. Since he was keeping track of our progress on a map, he had good reason not to be concerned, but I was not yet competent at reading contour lines and had no idea where we were.

After we climbed steeply for a few hundred feet, the terrain changed radically. We were now out of the steep-sided canyon, skiing through a broad opening I hoped was the pass. I glanced down the canyon one last time, again amazed by the distance we had covered. The view east was framed by the descending ridges of Gibbs and Lewis, which formed the almost perfect U-shape through which I gazed. Ahead, it looked like easy going.

Indeed, the final ski to Mono Pass was on the gentlest of slopes. Whitebark pines dotted the open expanse, and for a time as we skied through the broad saddle that straddled the Sierra crest, there was no view in either direction. Then, all at once, I had my first look at Yosemite National Park.

In contrast to the steep canyon we had ascended, the west side of Mono Pass was a gentle sweep of open terrain. Fingers of forest stretched up toward us, thickening into the distance. The land, as far as I could see, was covered with snow. Dominating all was the Kuna Crest, an elegant show of clean Yosemite granite. Tom, who had spent a lot of time around Tuolumne Meadows, happily identified the surrounding peaks and lakes. I lingered at the pass, taking it all in for the first time.

The following day as we stood atop Mammoth Peak, surrounded by the park, I was not prepared for its grandness; there was so much to see in every direction. The landscape, so familiar to me now, was on that spring day a dizzying jumble of peaks, lakes, and canyons. A deep snowpack blanketed most of what I saw; despite the warmth, it was still winter in the high country.

When our ski trip ended, we begged a ride down the Tioga Road, which had been cleared of snow from the east side to the entrance station. The plunging, curving descent into Lee Vining Canyon was exhilarating after four days of slogging with a backpack. There are no roads on the east coast with similar scenery or exposure; it was really quite a thrill. It had taken us the better part of a day to ski up Bloody Canyon, but the ride down the pass was over quickly, and suddenly we were in Lee Vining.

*N*ot long after the ski tour, Tioga Pass opened. Joining the line of cars at the entrance station, I bought my season pass and drove through to Tuolumne Meadows. Enamored with the region, I found a job for the summer waiting on tables and cleaning cabins at the rustic Tioga Pass Resort, just a couple of miles from the

Then, all at once, I had my first look at Yosemite National Park.

entrance station. Without any planning, I fell easily into an idyllic lifestyle of working and going for hikes.

As late spring gave way to summer in the high country, the snow melted, first at the lower elevations, and then higher and higher, until all that remained were persistent north-facing patches that I later learned were always there. The sun warmed the meadows green, and the most beautiful wildflowers I had ever seen appeared. The day-after-day pattern of endless blue sky and cool nights was broken by fierce thunderstorms that came in dramatic cycles of rumbling build-up, followed by great downpours of rain and hail. I loved these storms, so unlike the dreary, drizzling days I remembered from summers back east.

I hiked and explored all that summer. At first I cautiously chose destinations I could reach easily by trail. I was not yet convinced that it was possible to walk cross-country without getting scratched up, or worse yet, hopelessly lost. But I did not take long to discover the pleasures of leaving the trail.

The open, higher-elevation terrain beckoned, and soon I was hiking loops, crossing ridges, and climbing peaks. Much of my wandering was solo because of my schedule, and also because many of my friends were rock climbers not inclined to spend their time on long walks. I found that I enjoyed the freedom of wandering through the magnificent landscape by myself.

In these grand mountains there were times when I felt overwhelmed and uncomfortable. For example, picking my way through acres of giant talus, I would wonder why I was in this place that did not welcome human travel. I did not belong here! But the more I got around, the easier it became, and the challenge of overcoming a talus field to get to a certain destination drove me on. As I walked and scrambled my way through the Yosemite backcountry, I grew familiar with the landscape, and vistas were no longer seas of ridges and peaks without names.

I did not take long to discover the pleasures of leaving the trail.

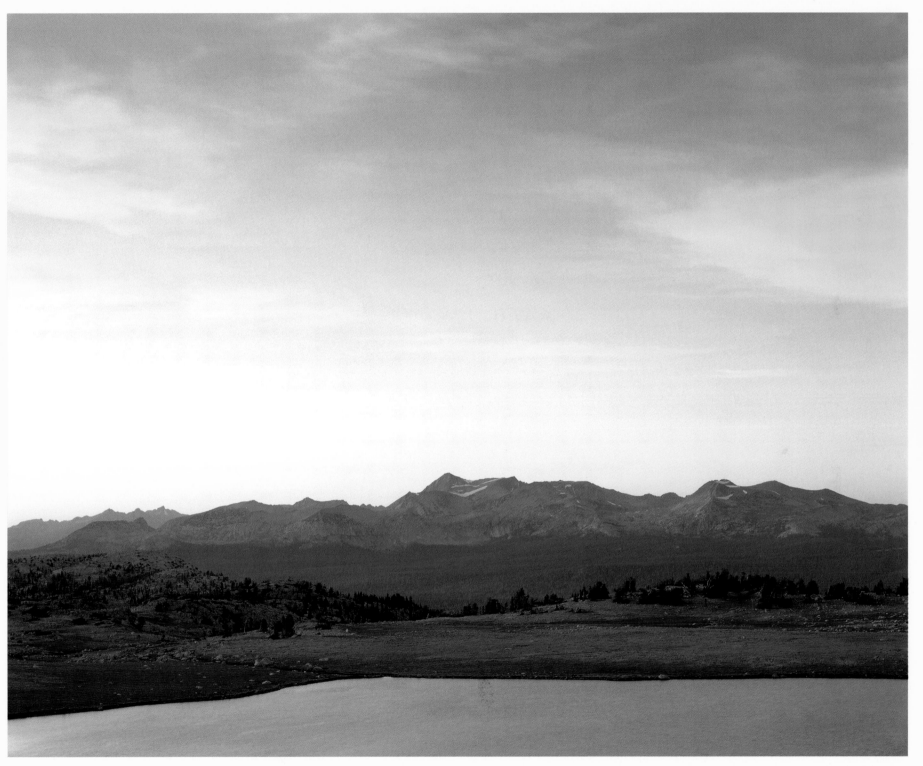

EVELYN LAKE

FOREST DETAIL, LYELL CANYON

The smaller details of the landscape surprised and captivated me the most.

Every corner of this country has its own character, I discovered. I was amazed at how easy it was, even in a popular place like Tuolumne Meadows, to find unspoiled wilderness. The main trail system drew the crowds. Leaving the trail, even for a short distance, was the answer. I loved the great features and landmarks of the park, but the smaller details of the landscape surprised and captivated me the most. The enchanting gardens, the exquisite tarns, the gleaming slabs, and the clear pools in a tumbling, noisy creek took me completely by surprise that first summer. Standing on top of Mammoth Peak earlier that spring, I had no idea that the surrounding landscape held so much in secrecy. I developed, through exploration, a sense of intimacy with this wonderful place.

I stayed long past summer's end at Tioga Pass, working to close the resort for winter. Accustomed to brilliant New England autumns, I was charmed by the change of the seasons in the high country. Strangely, I was not disappointed by the lack of flaming red, orange, and yellow trees. The change here was more subtle, the colors mellower. The golden landscapes of fall seemed warm with light, vastly different from the bright summer landscapes. It was the autumn light, the lower rays of the sun, that gave the Yosemite backcountry an almost magical beauty.

Knowing my days in the mountains were numbered, I was nudged by the shorter days and colder nights to take advantage of them. One October day I took a long walk to Mono Pass. I had returned many times over the summer to visit this area, always with great pleasure. Instead of following the trail straight to the pass, I decided to make a grand tour. It was a glorious day, sharp and cold in the early morning, but warming up quickly in the sun. The shady places in the forest still held patches of new snow from a recent brief storm.

WHITEBARK PINE DETAIL,
DANA FORK OF THE TUOLUMNE RIVER

The middle kingdom of Yosemite,

the place between talus and

snow, oaks and big granite,

is filled with convoluted

canyons, wind-beaten

divides, overgrown trails,

ancient summit registers,

and broken arrowheads.

I'm glad I've seen it.

It deserves to stay the way it is.

C.F.

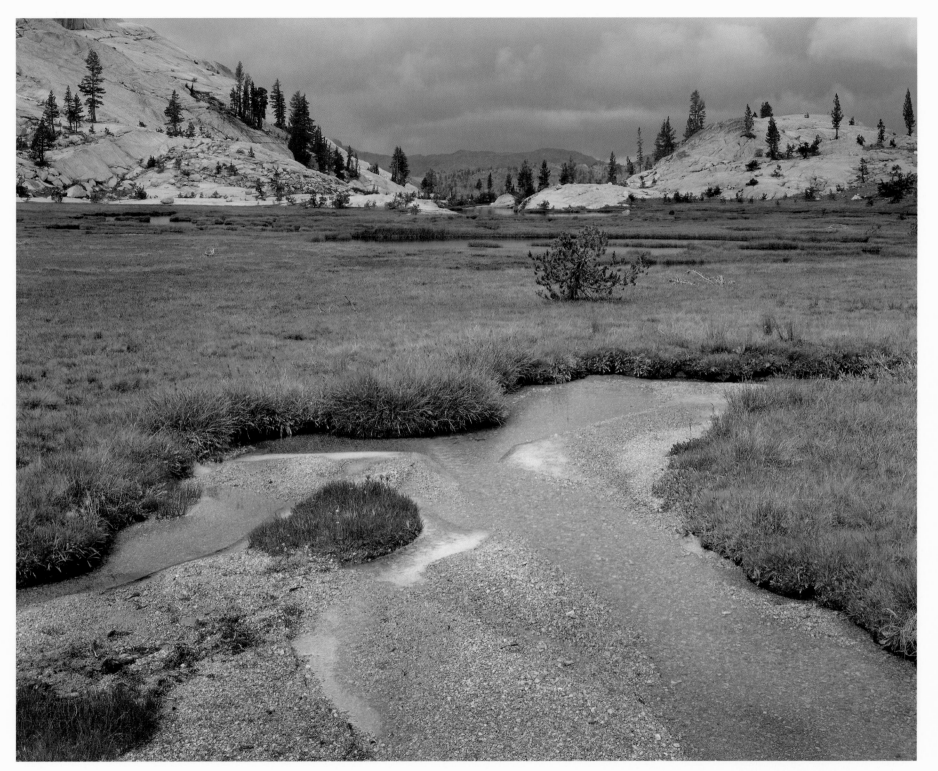

MEADOW ABOVE DOE LAKE

I crossed Parker Pass Creek, a tricky task in midsummer, but now, with the much-decreased flow of water, a matter of a few easy steps. Wandering up the forested slope on the opposite side, I listened for the sound of Kuna Creek off to my right. Following the sound of water, I left the forest and emerged into a flat, open area where the creek meandered aimlessly, doubling back on itself in the boulder-strewn meadow. The warm, golden grass beckoned me to stop and rest a while, but having set a big agenda for the day, I pressed on, pausing only to gaze into the deep pools where I knew fish always lurked.

Kuna Lake was my first stop. Nestled close under the granite walls of the Kuna Crest, this lake was a place I loved to visit. It felt protected and hidden, and I found its small, rocky island quite attractive. The climb from Kuna Lake to Bingaman Lake was steep but short, and it took me into an entirely different environment. As I wandered onto the high plateau in which Bingaman sits, I was struck by the exposure of the place. The terrain falls away on three sides of the plateau, and were it not for the peaks that rose above me in all directions, I would have felt on top of the world as I stood beside this windswept lake.

As I started down the steep hillside overlooking Spillway Lake, I found myself stopping to marvel at the view. From above, Spillway was a remarkable sight, completely surrounded by grass, without a single rock breaking up the border between shore and water. On this fall day, the lake was a sparkling blue pool of color against the muted gold of the meadowlands that stretched all the way to Parker Pass.

Spillway Lake tapered and curved toward its outlet, and I headed there to have lunch. Leaning against a boulder at the outlet, I savored the view of the rounded red bulks of Dana and Gibbs. Lulled by the warm sun, I was in no hurry to move on. When I finally gathered my things to leave, I noticed obsidian chips lying easily within my reach. This had obviously been someone else's seat before it was mine.

I was struck by the exposure of the place. The terrain falls away on three sides of the plateau.

One is never too old nor too young to see the backcountry of Yosemite for the first time.

Walking toward Mono Pass and the dilapidated cabins that stood there, I found myself thinking about the others who had used this pass, not pleasure seekers like myself, but those who had carried hunks of obsidian over the mountains, for this had been a major trade route across the Sierra crest. Then came the white men, who tried to hack gold out of these stern mountainsides. Their sad little cabins, built from whitebark pines, stand today as a reminder of their tenacity. Only a few months earlier, I had used this same pass to cross into Yosemite, just to see the sights. I had not known then about man's earlier business here.

What if I had never gone on that ski tour in May? What if I had never stayed to see the Yosemite backcountry in summer and fall? I did stay, and now I know that in late summer the meadows high on Mono Pass are dotted with gentians. I also know what it is like to walk the length of the Kuna Crest, to climb the final stony steps to the summit of Mount Conness, and to explore the saddle between Mounts Dana and Gibbs. By the end of that first summer, there was no need to convince me of the beauty of Yosemite's backcountry.

I have no childhood memories of camping in Tuolumne Meadows or of backpacking to Sunrise or Vogelsang. I discovered Yosemite almost by accident, then spent nine summers at Tioga Pass. Although that part of my life is over, I still live close to the park. One recent summer I walked through the park's backcountry, holding the hand of my three-year-old daughter. The camera captured images of us wading through waist-deep flowers in Spiller Canyon. It was my first trip to this place, and Laurel's as well. I hope she learns to love the Yosemite backcountry as her parents have.

Although the Yosemite experience is likely to be different for everyone, opportunity awaits anyone who dares leave the car, whether for a few steps or for miles and days into the wilderness. One is never too old nor too young to see the backcountry of Yosemite for the first time.

The Alder Creek Trail is not in Yosemite's famous high country. It lies between Wawona and Yosemite Valley in the lower-elevation part of the park that is covered with forest—ponderosa pine,

Walking with Laurel

sugar pine, incense cedar, white fir, black oak. Small streams trickle along the floors of forested ravines, staining boulders red with iron oxide. Trails aren't spectacular; they climb up through the forest to minor granite outcrops, or they traverse small, flower-filled meadows surrounded by tall firs and pines. Long vistas are glimpsed only through the branches of trees. It is relaxing country, and in some ways it feels more remote, more wild than the hiker-crowded high country. And hardly anyone ever goes there. My friend Laurel Boyers and I thought it was a good choice for our first long walk together in ten years.

BY ANNE MACQUARIE

MANZANITA, SOUTH FORK
OF THE MERCED RIVER

Laurel and I had worked together in Yosemite's backcountry program in 1976, issuing wilderness permits while sitting most of the day in the small gray structure affectionately known as "The Box," in the middle of a backpackers' parking lot at Tuolumne Meadows.

It was only the second year in which wilderness permits had been required in Yosemite, and the park service was gathering baseline information for a trailhead quota system that would limit the number of people setting off into the wilderness each day. The permit issuers gathered much of this information. We questioned each group about its destination and how many nights the hikers intended to stay in each "back-country use zone" ("I'm sorry, you can't sleep at Young Lakes on Tuesday, but maybe you could go over to Roosevelt Lake. . ."); went over the "backcountry use regulations" printed on the back of the permit; and made sure everyone knew how to hang their food from bears before we finally let them go. Most of the hikers were remarkably patient, and Laurel and I liked our jobs because we got to take a backcountry patrol twice a month.

The following spring Laurel and I competed for two jobs. One was as a backcountry ranger—a full-fledged backcountry ranger who would be in the wilderness all summer. No more permit issuing, no more "box." The other was to be in charge of all the permit issuers. The ranger job was a seasonal position and would never be anything else—three months each summer of walking around Yosemite's wilderness for a salary just enough above the minimum wage that it wasn't embarrassing, then back to unemployment or another part-time job in the winter. The permit issuer didn't get into the backcountry as much—seven or eight times a summer—but the position had the possibility of being "permanent"—a year-round job with health and retirement benefits.

It is relaxing country, and in some ways it feels more remote, more wild than the high country.

My days of wandering around alone as a backcountry ranger were gone forever.

I was drawn to the idea of walking around in the mountains all summer. Laurel was, too, but she also liked the idea of full-time employment. She applied for, and got, the position supervising permit operations; I applied for, and got, the ranger job.

I was a backcountry ranger in Yosemite for three summers and four winters; then I returned to graduate school and, immediately after that, had two children. My days of wandering around alone as a backcountry ranger were gone forever: my hiking experience now consisted mostly of telling long and exciting stories and doling out candy in order to keep the children walking along the trail.

Laurel has worked in Yosemite's wilderness for over twenty years and now manages it. She has a staff of twenty-four people, including patrol rangers, permit issuers, and a wilderness education specialist. We didn't see much of each other for years—I was in the city; she was in Yosemite. Recently I called her and suggested taking a hike.

I left the children with my parents for the day and met Laurel at the Mosquito Creek trailhead. She showed up in uniform—gray shirt, badge, brass-finish name plate, green hiking shorts, green cap—and with her radio and other ranger gear stowed in her pack. She was officially "on patrol." We walked uphill through a thick forest of tall sugar pines and ponderosa pines. Underneath them, skinny, sun-starved, young white firs and incense cedar crowded close together. Logs were down across the trail and dusty sunlight filtered through the trees. Near the top of a ridge, the trail turned and cut straight and even along the mountainside on an old railroad grade, probably built around 1914, when much of the southern part of the park had been logged by the Yosemite Lumber Company.

The railroad grade traversed the mountainside. We reached a clearing in the trees—granite outcrops, a stream, tiger lilies, blue lupine, and paintbrush—and stopped to look around.

61

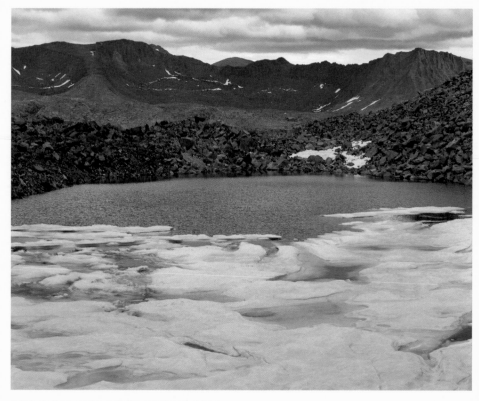

KOIP CREST FROM BELOW SIMMONS PEAK

The Cathedral Range,
where John Muir went to church,
is also my favorite
place to worship.

C.F.

WALL DETAIL, CATHEDRAL RANGE

 Part of a backcountry ranger's job is to pick up litter—any kind of litter.

"A good camping spot," said Laurel. "I wonder where the fire ring is?"

"Over there. No, that's the bathroom. Oh, well."

Part of a backcountry ranger's job is to pick up litter—any kind of litter. Laurel reached into her pack for a plastic bag and with the bag over her hand like a glove, picked up the soiled toilet paper.

"There are some parts about being a backcountry ranger that I don't miss," I said, watching her. (I'm ashamed to admit that I didn't offer to help.)

"What, you haven't picked up any used toilet paper lately?"

"I used to use two sticks, like chopsticks. Your method is more advanced."

"I guess we've made some progress over the years," she said, peeling the bag off her hand.

I thought about that hiker, here a few weeks ago, squatting in the woods. Who cares about the toilet paper left behind? This is the wilderness—who'll see it? But hungry and curious squirrels or maybe a bear came to dig up his waste and scatter it about, followed a few weeks later by a backcountry ranger to pick up after him.

"So much for the bathroom," Laurel said. "I wonder where the kitchen is? Ah, right there."

As we approached the ring of fire-blackened rocks, I said, "Let's make a bet. How much trash?"

Laurel stopped and regarded the ring from thirty feet away. "It won't be a bad one," she said. "Maybe some tin foil."

When we got to the fire ring there was only gray ash and a few charred bits of aluminum foil. "Twenty-some years experience," I said.

When Laurel and I worked together in Yosemite, the park service had just implemented a policy prohibiting campfires above 9,600 feet. There is not much wood above that elevation in the High Sierra, and hardy, twisted whitebark pines around places like Boothe Lake, Ireland Lake, and Cathedral Lake (trees that had survived years of winter storms and summer droughts), were being ripped apart for firewood. The park service chose 9,600 feet because it is one of the thick contour lines on U.S.G.S. maps—easy to relate to one's location. We were directed to tear apart all fire rings above that elevation.

It was extremely dirty work, and it was especially discouraging to rip apart a fire ring at a popular lake one week and come back the next to find two in its place. We kept a daily tally of fire rings destroyed. I got some satisfaction out of a large count of thirty or so, as long as I could find a private spot later where I could strip and bathe, and a patch of clean sand to scrub the charcoal off my hands.

The mother of all fire rings was at Nelson Lake, and I didn't attack it for a long time. Nelson Lake, while not on an official trail, is reached by a well-worn "use trail," and at only six miles from Tuolumne Meadows amid the white granite peaks of the Cathedral Range, it's a popular backpacking destination. The shallow, meadow-edged lake reflects the blue Sierra sky. Groves of lodgepole and whitebark pine surround the meadow; above them rise the dihedrals and pinnacles of a nameless white peak.

The ring was an imposing rock structure, more hearth than fire ring—it would not have looked out of place as the centerpiece of a rustic mountain lodge. It stood about waist high, built up to that level by generations of campers. The stones at the base were huge and black, covered with charcoal from countless fires. Above them were smaller stones, becoming progressively lighter in shade toward the top. The ground around the ring was trampled and so full of soot that on a dry day it puffed black when walked upon. The lower limbs of most of the surrounding trees had been hacked off.

We were directed to tear apart all fire rings above the 9,600 foot elevation.

Throughout most of that summer I compromised. I told myself I'd break up all the other fire rings at Nelson Lake, each and every one. I told myself I'd at least keep the mother of all fire rings clean. The campsite might have been trampled and sadly denuded, but it was clean.

One day I arrived at Nelson Lake early, sat down next to the massive structure, and pulled out the map. "It isn't at all clear," I muttered to myself, "that this campsite is above 9,600 feet. In fact," I bent over the map with dawning hope, "I really don't think it is."

Then I noticed the little blue numbers printed right on the lake—9636. I looked up from the map at the bare ground and the hacked-up trees, and understood I could put it off no longer.

It was the end of the summer. My fire ring eradication efforts had become haphazard—I'd kick stones, scatter charcoal, and be done with it. That wouldn't work here. This fire ring had tugged at my conscience all summer—it was necessary to do the job right. I moved my backpack to a clean patch of ground far from the campsite, pulled on gloves, and went to work.

I began with the small stones and carried them as far as I could in all directions. As the deconstruction continued, I found that the ring was so full of ash and charcoal that I had to load up and carry off several plastic bags full of the sodden, black grime in order to uncover the big foundation boulders.

By the time I got down to the base of the structure I was running out of places to put the debris. I thought of the "Cat in the Hat" book where the cat introduced a pink substance into the children's house and, in his efforts to clean it up before their mother returned, made the whole place pink. I could almost see Nelson Lake turning gray under the ash. I considered dumping the biggest, blackest stones in the lake but

I looked up from the map at the bare ground and the hacked-up trees, and understood I could put it off no longer.

DETAIL, SOUTH FORK OF THE MERCED RIVER

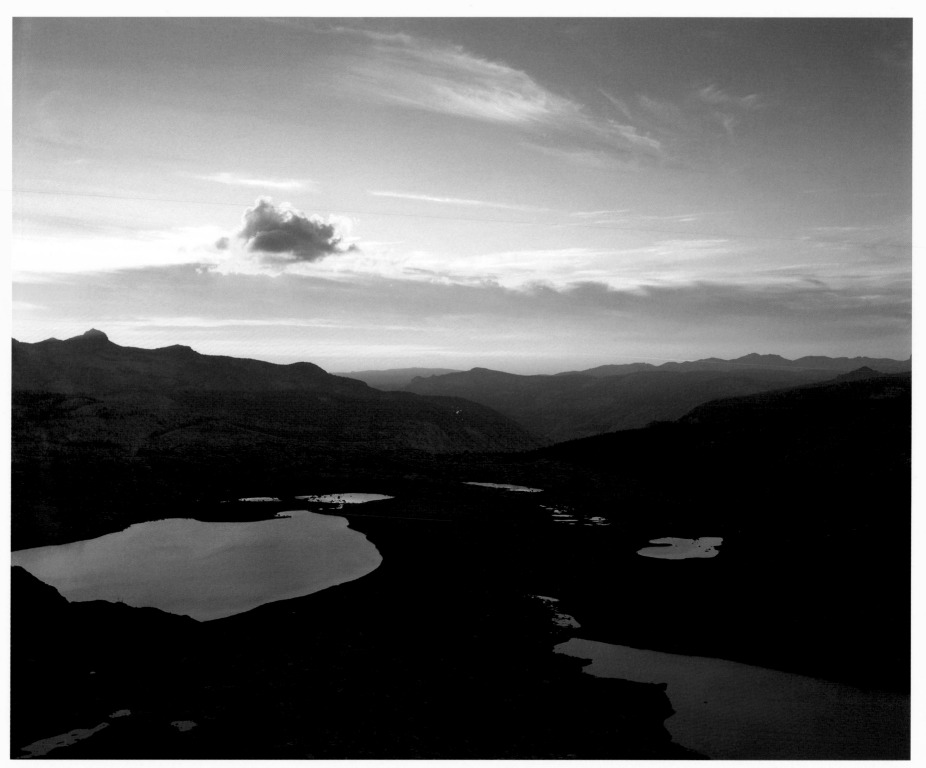

SUNSET FROM ABOVE HARRIET LAKE

decided against it, so I dragged them as far as I could and left them to be cleaned slowly by summer thunderstorms and winter snow pack.

Finally I smoothed the ground, scattered pine needles over the black dust, and sat down, a few hours and 180 rocks later. My summer was complete.

The Alder Creek Trail continued along the railroad grade while the slope below dropped away. Through the trees we could see that we were crossing the head of a bowl-shaped valley that tipped toward the canyon of the south fork of the Merced River. The trail left the forest at the top of a granite outcrop, and below us was Alder Creek Falls.

"Do you think we could get down to the base of it?" I asked Laurel.

We looked down at a steep, gravelly couloir descending through the cliff band at our feet, then at the boxcar-sized boulders protecting the base of the falls.

"We could," she answered, "but do we want to?"

We sat down at the side of the trail to eat lunch. A Steller's jay called. A ground squirrel investigated the crumb possibilities.

"It's great to get out," Laurel said. "I've been spending too much time in the office."

"And I've been spending too much time at home."

I looked across the valley, hoping to catch a glimpse of the high peaks where I had spent so much time as a ranger. I asked Laurel how the Yosemite wilderness had changed in the many years she's been working in it.

She told me that there are not as many people; the number of wilderness visitors in 1996 was two-thirds what it was in 1977. I remembered the mother of all fire rings at Nelson Lake, then thought of a walk I had taken the previous summer to Upper Cathedral Lake, a heavily-used lake only a few miles from Tuolumne Meadows.

I told Laurel I thought Cathedral Lake was looking great and asked, "Do you think it's because there are fewer people there now?"

"Maybe," Laurel said. "But I think it's because we had a restoration crew up there a few summers ago."

"A what?"

Laurel told me that backcountry rangers still clean up campsites on their regular patrols, like we used to back in the 1970s, but now the park service has "restoration crews" that camp out all summer, cleaning up, restoring, and revegetating popular campsites. Cathedral Lake was cleaned by a crew paid for by the Yosemite Fund.

She told me that Yosemite also gets funding for wilderness restoration from the city of San Francisco. Just over half the Yosemite wilderness lies in the Tuolumne River watershed, and the Tuolumne is San Francisco's water supply. Although the water is remarkably pure, San Francisco is still required by the Clean Water Act either to filter its drinking water, or to do "filtration avoidance" by managing the Tuolumne watershed to control and eliminate surface contaminants.

"So the city gives the park service almost a million dollars a year to do things we should be doing anyway," said Laurel, "like sewer repair, backcountry patrols, and campsite rehab."

I asked her about the results of the watershed management. How many sites have been cleaned up? Do they stay clean?

She mentioned that the park service has done a number of studies of Yosemite's backcountry campsites. The first study, an inventory carried out in the mid-1970s, identified 5,000 campsites. Then, in the 1980s, the park service began a "Wilderness Impacts Monitoring System"—another inventory of Yosemite's trails and wilderness

Do backpackers have any idea they're using campsites that have been so inventoried, surveyed, and rehabilitated?

campsites. Sites were rated according to eleven measurements of human impact—things like mutilation of rocks and trees, number of use trails, size of the fire rings, and the amount of bare ground at the site.

Finally, in the 1990s, the park service picked thirty sites for which data was available from the previous studies and compared their condition over the three decades.

"Big surprise," said Laurel. "The Tuolumne drainage, with its heavy funding from the city, looks pretty good. The Merced drainage is better in some places and worse in others."

"I wonder if backpackers have any idea they're using campsites that have been so inventoried, surveyed, and rehabilitated?"

"Nope," replied Laurel, "I'm pretty sure they don't. This is the wilderness, right?"

We talked about what it means to "manage" a wilderness. Laurel explained that the Yosemite backcountry is managed for all the attributes that make it a wilderness— watershed, solitude, silence, habitat. Just then a passenger jet flew over and she said, "But listen to that, for instance. A few years ago we did a study of aircraft noise in Yosemite. Did you know that you can hear airplanes fifty-four percent of the time in the backcountry?"

I remembered the winters I spent in Tuolumne Meadows as a ski patrol ranger. In my memory the winter sky over Yosemite is pale to deep blue, with white vapor stripes. "But what can you do about it?" I asked.

Laurel shrugged. "Remember all those times you've flown out of San Francisco or Fresno and the pilot comes on and says '. . .and if you look out to the left you'll see Yosemite Valley.' What can you do if you're on major air routes in the most populous state in the country?"

71

"At least the airplane noise isn't as bad as in the Grand Canyon," I said.

Laurel agreed. But she's frustrated sometimes. She wants to see the Yosemite wilderness become more "charismatic" so that park service decision-makers will pay more attention to it. With the constant work in the more-populated areas of the park—urban-style traffic in Yosemite Valley, fires, cliff rescues, endless master planning efforts, deteriorating infrastructure—it often seems to her that wilderness is ignored because it's not in crisis.

Park managers, like many of us, may prefer to think of wilderness as serene and unchanging, a place to escape from daily life. But those who actually spend a lot of time in undeveloped and unspoiled areas, like Laurel and all the other wilderness and backcountry rangers, understand that while wilderness might be "primeval" by legal definition, it is, in fact, part of a crowded world full of people.

We finished our lunch and continued along the trail. Where Alder Creek plunged over the lip of the falls, the railroad grade ended and the trail narrowed, leading above the creek through a meadow of tall lupine, goldenrod, and leopard lilies. As we stopped to admire the lilies, Laurel noticed a paw print in the mud on the trail. We bent down to look closer.

"Coyote?"

"Too big."

"We saw those horse prints back there—maybe they had a dog along with them."

"Could be. But the print looks different from a dog's. Broader."

A few yards further along, a pile of fresh scat lay partially buried in the middle of the trail, scratch marks in the dirt beside it. We looked at each other. "Cat."

We straightened up and scanned our surroundings, the waist-high lupine and tall willows by the creek, the forest on the slope above us, the narrow trail ahead.

"It changes the feel of a place, doesn't it?"

We walked on, silent for a while, until we came around a corner and saw a man and

While wilderness might be "primeval" by legal definition, it is, in fact, part of a crowded world full of people.

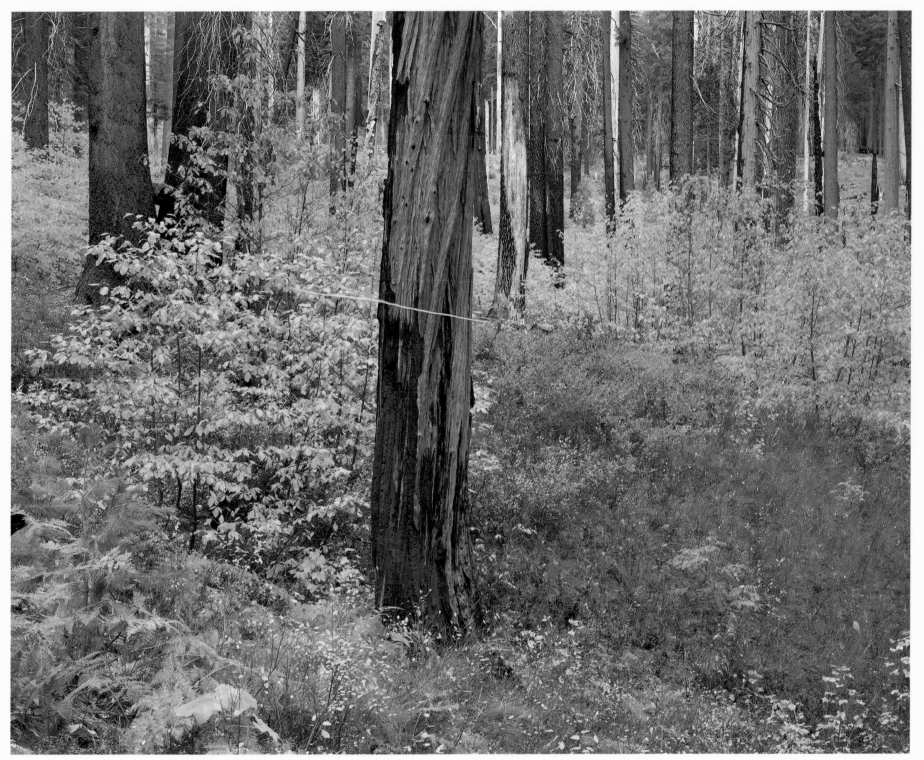

FOREST NEAR CRANE FLAT

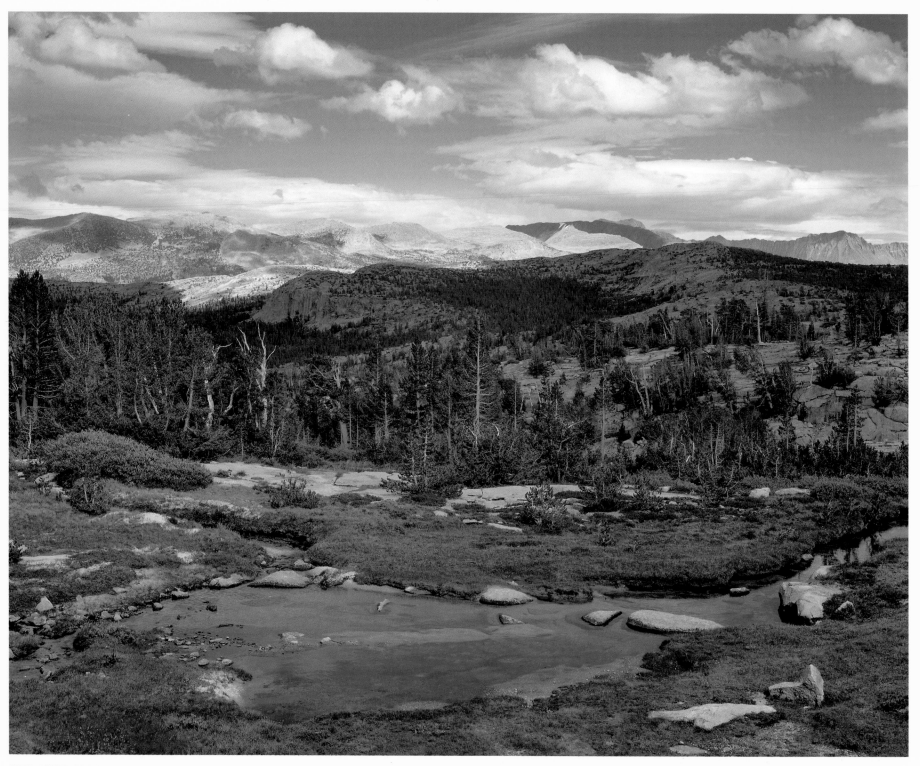

KOIP CREST FROM BELOW JOHNSON PEAK

I stepped behind a tree and watched three backpackers pass.

a boy fishing down by the creek. They were the first people we had seen all day. "Aha," Laurel said, "visitor contact."

She called down to them. "Catch anything?"

The boy called back proudly, "I got one."

"Good for you," Laurel answered. "Are you just in for the day or are you camped around here?"

"We're here for a few days," said the man, "with the llamas."

Watching Laurel slip so smoothly into her backcountry ranger role as soon as she saw people reminded me of my own solitary days as a backcountry ranger. "Visitor contact" was an important part of the job.

I worked alone, and since I patrolled on foot, there was not even a horse to talk to. The chatter on my N.P.S. radio was my only company. And that chatter was mostly one way—I listened but couldn't talk back. Yosemite's rugged topography is full of holes out of which a little hand-held radio has no hope of reaching the repeater on top of Mount Hoffmann.

I didn't mind the solitude. In fact, I got so used to it that I almost forgot how to talk to people. Once, returning home along the Pacific Crest Trail after a long patrol, I heard voices approaching on the trail. Without even thinking about it, I stepped behind a tree and watched three backpackers pass. As their voices faded away I wondered, "Why did I do that?"

But mostly, like Laurel, I forced myself to talk to everyone I met. I had some interesting conversations. There was the young Texan I met at Irwin Bright Lake, in the remote part of Yosemite's wilderness north of the Tuolumne River's Grand Canyon. He had been at the lake for three days, he told me, fishing.

POND DETAIL, NEAR SMEDBERG LAKE

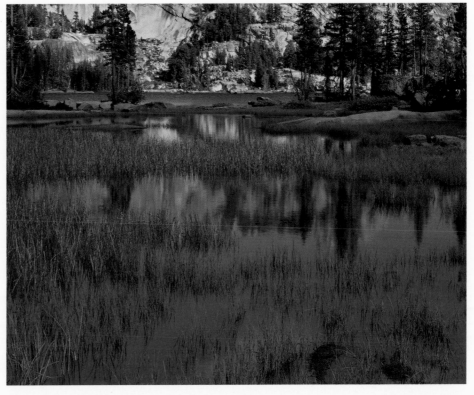

SMEDBERG LAKE

Smedberg Lake sits alongside
the Pacific Crest Trail.
Although popular, Smedberg is a
perfect representative of what lies
off the beaten paths of Yosemite.
I was completely surprised to find
that the backcountry of Yosemite
is wilder and more pristine than
most of the rest of the Sierra.

C.F.

I looked around his campsite and noticed two dead rattlesnakes draped over a boulder. "Where did those snakes come from?" I asked.

"I got 'em down by the lake," he answered.

"Why did you kill them?"

"Ma'am," he said, "where I come from we kill rattlesnakes."

"But this is a national park," I said, "and the animals are protected."

He looked at me in disbelief. "Even rattlesnakes?"

"Even rattlesnakes. This is their home. They belong here. I could give you a ticket for killing those snakes."

He shook his head. "Sure is different here in California."

I didn't give him a ticket, though. Instead, he gave me a cup of coffee. "You're the first person I've seen in four days," he said. "Stay and talk awhile."

I talked with him about Yosemite and its animals, about how every creature has its role in an ecosystem and so on, trying to get across a little lesson in basic ecology. He told me stories about crawling through tunnels in thick brush with a rifle in his hand, hunting pigs with his uncle.

"What you have to watch out for," he said, "is when the pig you're following gets mad and turns around and comes after you."

I learned something I never knew about boar hunting in Texas, and he, I hope, learned something he never knew about why you don't always kill snakes.

But today on the Alder Creek Trail Laurel and I met very few people, and our conversation was almost uninterrupted. Walking and talking, we got to the base of the steep climb over Chilnualna Mountain and realized it was already late afternoon. We decided to go back the way we'd come.

I learned something I never knew about boar hunting in Texas.

We had seen only eleven people—and the prints of a mountain lion.

We walked down out of a lodgepole forest into red firs, then into the mixed conifers below that. At a trail junction dominated by ponderosa pine and black oak we decided to walk to Wawona rather than descending to the trailhead on the road below.

Fingers of chaparral reached up into the forest from the canyon floor—manzanita, ceanothus, chinquapin. The pungent scent of kit-kit-dizze filled the air. In the end-of-the-day trance induced by fatigue and the rhythm of walking, my mind roved over the whole of Yosemite's backcountry. Today I had missed the glittering white granite and the endless, open alpine meadows familiar from my days as a backcountry ranger. But then I remembered walking out from the Glen Aulin High Sierra Camp one August day and counting almost a hundred people in the five miles to Tuolumne Meadows. Today, in this dusty forest, we had seen only eleven people—and the prints of a mountain lion.

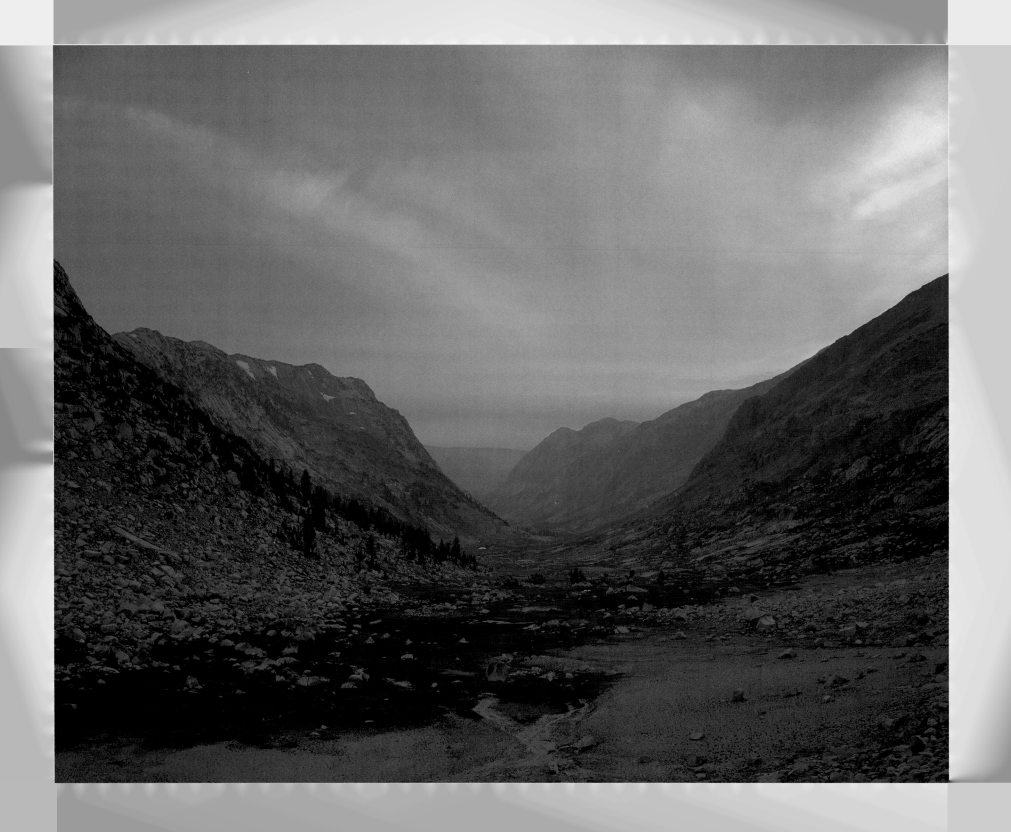

When I told people I planned to hike in to whatever spot in Yosemite National Park was farthest away from any road, a common reaction was this: I know exactly where it is, and don't you dare write about it.

Heart of Brightness

I sympathized with the protective reflex. Publicity is bad medicine for wilderness, sometimes. I would hate to be the one to put on the map some photogenic, fragile, hitherto neglected place. But before sitting down to wrestle with my conscience, I thought I'd at least figure out where the most remote spot might be. Unlike my informants, I didn't think I knew exactly where it was; in fact, I had no idea. Some knowledgeable folk thought the farthest-in point might be in the Clark Range near the southern boundary of the park. Others placed it near Benson Lake on the Pacific Crest Trail,

BY JOHN HART

STUBBLEFIELD CANYON

known for its big granite-sand beach (the best in the Sierra, they say). Still others nominated trail-less ridges up around Tower Peak on the park's northern fringe.

Enough supposing. I went to the maps. I taped together several topographical sheets into a mosaic, had it reduced to a manageable size, and went to work on it with markers. By outlining all the marginal roads, I also outlined what was roadless: two big irregular blobs of territory, one north and one south of the Tioga Pass Road. Each outline included not only parkland but also adjacent roadless areas managed by the U.S. Forest Service. To my surprise, the northern blob, though smaller in acreage, was better arranged to provide remoteness, being less gnawed into by intruding roads. Its 1,100 square miles or so form a real wilderness stronghold.

Concentrating now on this northern region, I started measuring. Drawing a series of arcs from road-ends and road-elbows, I found out how much of the region was ten miles away from auto access (quite a bit); how much was eleven miles deep (a much smaller polygon); how much was twelve miles in (only a couple of square miles). At just over thirteen miles, the core zone dwindled to a point—the pole of remoteness, the heart of the wild.

There are just two other places in California—both in the southern Sierra Nevada— where you can get this far from a road. In the United States outside of Alaska, there are no more than ten such places. The deepest wilderness in the Lower Forty-Eight is southeast of Yellowstone National Park, and even there you can only get twenty-one miles in, as the raven flies, before you start coming out again. It is a discouraging thought.

I was relieved, though, to find my Yosemite midpoint where I did: not on some alpine peak, not far up some trackless canyon, but on a lesser ridgeline, a few miles south of the northern tip of the park, near the outlet of long, fjord-like Tilden Lake,

I planned to hike in to whatever spot in Yosemite National Park was farthest away from any road.

It was what I had hoped for: a place whose significance was accidental.

and within a mile or two of the Pacific Crest Trail. It was what I had hoped for: a place whose significance was accidental—a spot unlikely to be lovelier or more remarkable than anything around it, notable only as an abstract marker. Surely, in describing such a spot, I wouldn't draw other people behind me. Why should it be the object of any second pilgrimage, after mine?

There are half a dozen reasonable ways to get in to the Tilden Lake area—the center is what can be reached from any side—but I had some druthers. I wanted to hike exclusively in the national park. I wanted to start down low and climb through several zones of trees and vegetation. I wanted to walk a loop, not repeating my steps. And I needed to finish the excursion in five days. My desires dictated just one possible approach: from the southwest, up out of the Tuolumne River Canyon at Hetch Hetchy—the place once called "the other Yosemite Valley." I would start at O'Shaughnessy Dam, at 3,800 feet, at the foot of the reservoir that pierces the flank of the mountains here like an enormous thorn. Leaving the flooded canyon, I would take the Beehive Trail northward, up along the drainage of Falls Creek. It was a region I long had wanted to know better, anyhow.

It has always seemed to me, when I put on a pack, that I have found a use for an otherwise wasted piece of my anatomy. The front side of a human body is a busy neighborhood, studded with sensory inputs, useful attachments, decorations. We *face* each other and the world. But the human back is just there: holding the whole structure up, to be sure, but superficially a blank. All that space ought to be good for something besides T-shirt advertising. When you hang a pack on it, it's like a completion, something God or the evolutionary dæmon must have had in mind from the start.

83

WHITEBARK PINE DETAIL, MACLURE CREEK

I've tried for many years

to capture images of crusty lichens

and of a weathered root system.

These are the only two photographs

that I have made in my

seventeen-year search.

C.F.

LICHENS, RETURN LAKE

85

At Hetch Hetchy Reservoir, the sense of wildness is slow to appear.

Not that the pack I am putting on is much of a burden. I happen to be the possessor of an artificial knee, and one of the rules for the differently kneed is this: Thou shalt not tote more than twenty-five pounds. This trip will be my first extended backpack since the surgery. This fact adds to the jaunt an edge of pleasure, a faint tang of suspense, that a hike of this length and difficulty would not otherwise afford.

I've spent a rainy pre-departure night at the backpackers' campground just above the dam. I've weighed my load, pulled things out of it, reweighed, and pruned again. I reluctantly omit the plastic bearproof food canister, strongly recommended in these parts but for me impossibly heavy. At the last minute, looking at the still unpromising sky, I restore one item: a waterproof, breathable bivouac sack to protect my brand-new, ultralight, superb, but very moisture-sensitive goosedown sleeping bag.

Done tinkering at last, I hoist the modest load, trudge down the jarring asphalt of the road, and cross the mighty dam. Halfway along, I stop to look down the implacable concrete face. Three hundred feet below, the Tuolumne emerges from its trip through the powerhouse, a white jet blasting from the canyon wall.

At the far end of the dam, the roadway penetrates a granite spur: a nice symbolic gateway to the wilderness. Beyond the tunnel, cars are barred. But the sense of wildness is slow to appear. The road doesn't really dwindle to a trail. Slabs of pavement remain. Side streams pass under the path in quaint concrete ditches roofed with cast-iron grills. And on ahead stretches that most unnatural apparition, Hetch Hetchy Reservoir, winding grayly on up into the Tuolumne Canyon.

In 1910, when the city of San Francisco had almost but not quite won the right to build the dam, a British traveler named J. Smeaton Chase traversed this region. Throughout this trip I will be following his steps, more or less, and seeing what he saw.

But I have to turn to his book *Yosemite Trails* for a sensation of the landscape that is drowned beneath that uncommunicative water: the huge, tentacular black oaks, the meadows of bracken and lupine, the roadless vistas, the wide, deep, silent river.

Los Angeles has been cast as a villain for the way it reached for water on the eastern side of these mountains, from Owens Valley to the Mono Basin. San Francisco, pursuing the same course on the western side, and in a national park to boot, has somehow escaped this blackening of name.

I wish I could say I do not find the reservoir beautiful. But that much water, curving among the cliffs and domes, cannot be otherwise. You could almost overlook the fifteen-foot bathtub ring where the lake level, rising and falling each season under human control, scrubs the banks of vegetation. Glimpsed from above or through a screen of trees or out of the corner of your eye, reflecting the crags or roughened by wind to a general brightness, this lake can make you forget its origin, its history.

*E*vening, the second day. I'm camped in the rain halfway up Falls Creek, legs poked into the warmth of dry goose down, eating one of my stoveless picnic dinners, watching the lightning open its sudden doors.

The hike has continued as it began: with a constant threat and frequent fact of rain. It's not yet October, but I'm told it has already snowed on the heights. Clouds and sunlight fight it out all day, constantly reshuffling my sky. Underneath, the country glistens, and it brims. I have lost count of the places where the flooded trail has forced me to wade shin-deep, or to search for the way around that tramples the least fresh grass.

Two days out? It feels like a week. Barring a few brief meetings, I've been alone, and solitude speeds up the natural unclenching of the mind. And the way the Falls

Two days out? I've been alone, and solitude speeds up the natural unclenching of the mind.

FALL COLOR ALONG TILDEN CREEK

Creek country has unfolded, page by contrasting page, makes Hetch Hetchy seem already far below and far away.

At noon yesterday, I was still climbing out of the Tuolumne gorge. The landscape there was dun and olive, Californian. The plants were largely those familiar from my coastal home: live oak and poison oak and wild honeysuckle, madrone and sycamore and bay, manzanita and short annual grasses. I had heard how hot this climb can be, and was glad for the cool shadows of the sky.

One o'clock. Above the canyon rim lay the gentler stretch I thought of as the Yellow Country. The trees were mostly ponderosa pines, massive columns, plate-barked and tawny. Beneath them grew bushes like oval-leafed snowberry and ferny kit-kit-dizze, which is supposed to smell like a bear. A tithe of the forest was dead and black, snags killed in a recent fire.

Two o'clock. The first shallow pond, and a sudden change of colors, as if I'd crossed one of the interior boundaries of Oz. Ahead it was green on green: the ground all bracken and azalea and corn lily; trees mostly true firs, red and white, and Douglas firs. But the charred snags were here, too. Staghorn lichen, as if laid on by a green north wind, softened the living but not the blackened boles.

Eleven this morning. Moraine Ridge, broad-backed, open-forested. It's a curious inward salient of the yellow-pine landscape, spared by the glaciers that gouged and scraped on either side. All around it is austerer country, the land without soil almost, the real Sierra. Below to the southeast lies big Lake Vernon on Falls Creek, where I had spent the previous night. Looking down to its polished granite and sparse woods is like looking up to timberline.

One o'clock this afternoon. Preliminaries over, the trail spilled me off Moraine Ridge into the upper valley of Falls Creek, the slot called Jack Main Canyon, and the classic Sierra.

I had heard how hot this climb can be, and was glad for the cool shadows of the sky.

Falls Creek has 6,000 feet of elevation to lose between its sources near Bond Pass on the northern park boundary and its final plunge into Hetch Hetchy at Wapama Falls. That's a lot of cascading, a lot of noisy water. But for several miles in lower Jack Main Canyon, the stream falls silent. This section of the valley lies across, not up and down, the slope of the Sierra. A long, deep lake must have filled it once—you can tell by the level floor, the sandy soil. Even now it seems half drowned. Everywhere are fragments and scraps of lakes, placid oxbows of stream, wet meadows gleaming around remnant central ponds. At one point I walked on a thin peninsula, no wider than a levee, between a quiet lake on one side and the equally quiet creek on the other; aspens lined the path like a planted avenue.

"I have been unable to discover who Jack Main was," wrote J. Smeaton Chase after his 1910 visit, "but I strongly commend his taste in canyons."

The hiker works harder here than the stream does, climbing granite noses, threading little woods of incense cedar or lodgepole or western white pine, passing the flowery spots that Chase called "half-acre gardens." By the time I heard the sound of water again, with a steeper gradient ahead, I was glad it was time to stop.

After dinner, hauling my bear bag into the dripping branches of a cedar, I startle myself by thinking: I could do this forever. What more do I require than to make and break camp, to give my body what it needs to live, to chart the day's destination, to move always on? How easy, how involving, how *comfortable* it all is. At this moment, everything I have valued that requires more of me—family, friends, books, poetry, music, the engrossing fabric of anyone's real life—seems eerily expendable. I am taken aback at my treachery.

After dinner, I startled myself by thinking: I could do this forever.

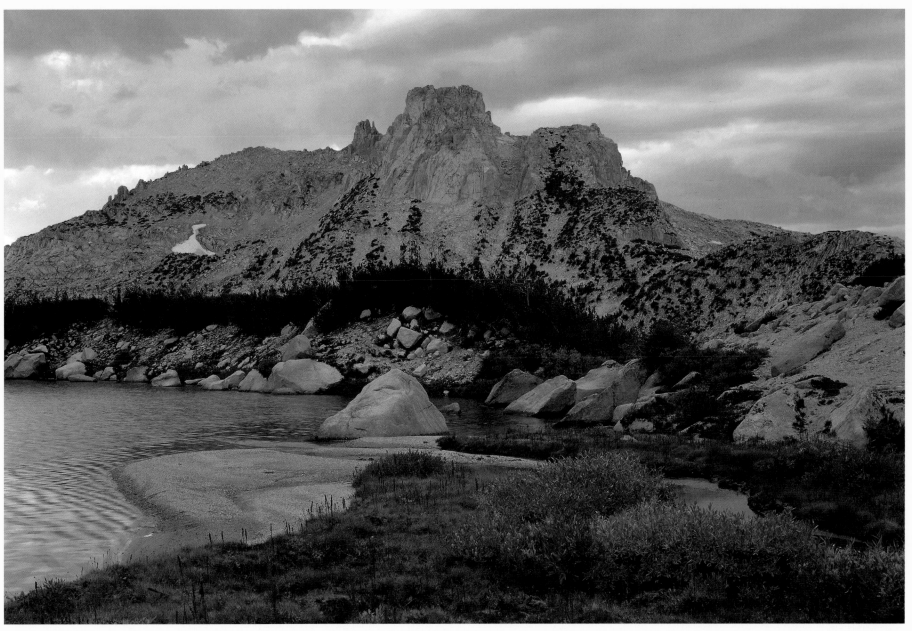

TOWER PEAK

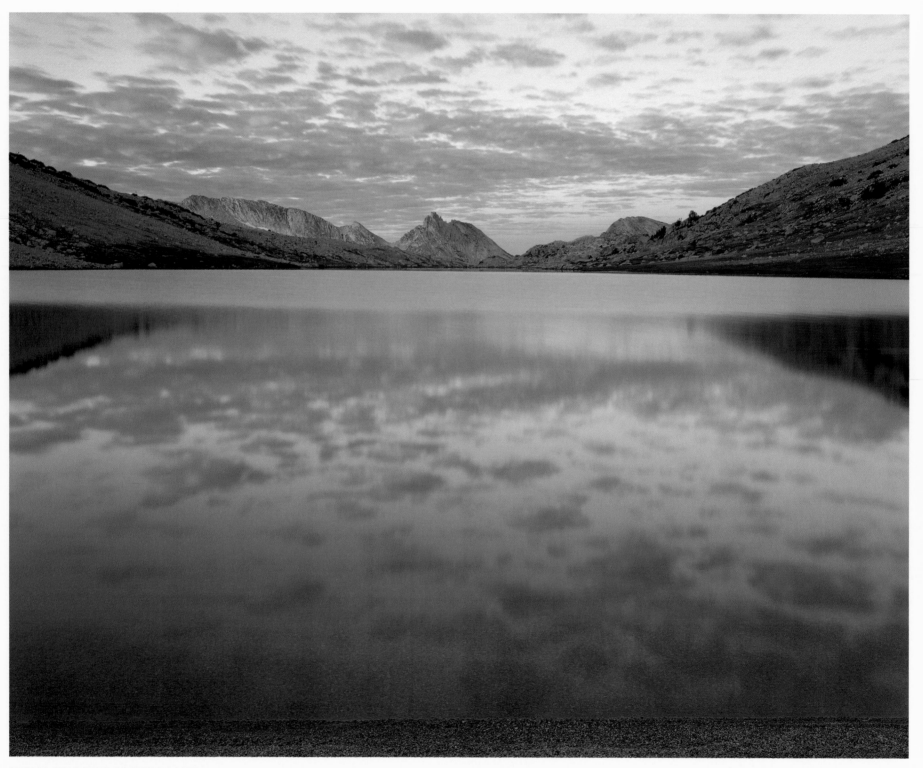

RAGGED PEAK FROM ROOSEVELT LAKE

I might have time for the summit. Why not, this once, let it be? I climb it, of course.

On the third afternoon I reach the outlet of Tilden Lake, a long digit of water pointing toward the great stack of Tower Peak. So says the map, so says Chase, but I will never see Tower in these clouds. Near the lake's outlet is the northern end of Bailey Ridge, a summit with three pale shoulders. Across the water to the north is the sharper form of Chittenden Peak, its triangular southern face attractively daunting.

At one point in the map work, I thought that Chittenden Peak might be my point of greatest remoteness. That would have been ironic, for Major Hiram Martin Chittenden was by no means a friend of the Yosemite wilderness. In 1904, as the head of a boundary study commission, he advised an all-too-willing Congress to reduce by one quarter the area of the park, removing some of the finest alpine scenery (the Ritter Range!) and also a vast swath of lower country, including most of the timber belt and much of the best winter wildlife habitat. While some of the alpine terrain would gain protection under another label, as forest service wilderness, the foothill and forest country would not do so well. It was an already-diminished park against which San Francisco would shortly mount its dam-building raid.

Still, Chittenden the peak is likable. A line of fractures across the face suggests a non-technical route to the top. I might have time for the summit. . .there is already thunder somewhere. . .it occurs to me that to pass up this ascent, to leave to the imagination the feel of that stone beneath my hands, would be a mark of spiritual progress. Why not, this once, let it be?

I climb it, of course.

Afterward, I get my tarp up just in advance of the afternoon storm. My little roof rattles and leaps in the wind. Sunlight strikes across gray air with the peculiar hard-edged quality that tells you it is ice, not water, that is doing the refracting. My ceiling

93

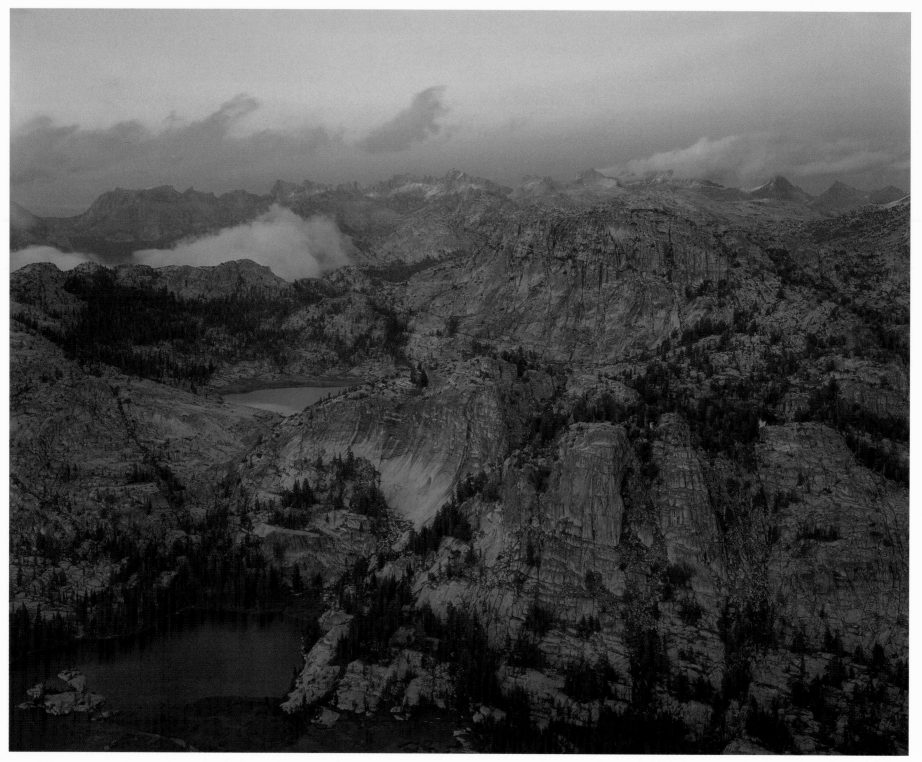

NORTHERN BOUNDARY COUNTRY FROM VOLUNTEER PEAK

Somewhere on this gentler reach is the innermost spot in the Yosemite wilderness.

bellies down beneath a snow-like load of hail; I kick upward to knock it loose. At evening, the sky clears westward and the Chittenden face seems to move closer, lit in every line. The glow in it is green.

I wake up on the fourth day thinking of things I shouldn't have in mind, not yet: unfinished business back home. Stop that, I tell myself. You have one night still, maybe two. And you haven't yet come to the center of the world.

Slogging and squelching along the edge of Tilden Lake—like so many others along the way, it has overflowed the trail—I feel the coming of winter. I am wearing every piece of clothing I have brought. The lake runs north between ridges gray with hail—or is it snow?—like a spur of the Baltic Sea.

The trail turns southward up a grassy opening. To my right, to the west, is the swell of Bailey Ridge, stepping down from its rugged northern tip. Somewhere on this gentler reach, according to my maps, is the innermost spot in the Yosemite wilderness.

I strike out cross-country over sloping, walkable slabs. Pause to admire a series of pocket flats, each with its two or three fine pines or hemlocks. The sun comes out and I at last get warm. After a quarter of a mile, I know that I need go no farther: given my rough cartography, any place within 500 yards might be the actual target. But I keep on going, looking after all for a spot with distinction, a place I will especially remember.

I wander on up to a notch south of the tri-horn peak. Up a granite bulge to the left. The local stone is slanted, jointed, brownish, here gleaming with glacial polish, there speckled with darker enclosures of black or red. There are little pockets in it; some contain a cup or two of water. I saunter up a second crystalline bulge.

It's a modest granite top. A cliff drops to the east. A couple of whitebark pines twist out of cracks, like driftwood come back to life. At the very high point, in a natural

ROCK DETAIL, HELEN LAKE

As a Tuolumne climber,
I examined a lot of rock
very closely. As a photographer,
I'm glad that a handhold,
foothold, or climbable route
doesn't matter. Even making a
photograph doesn't matter.
The rock is still beautiful.

C.F.

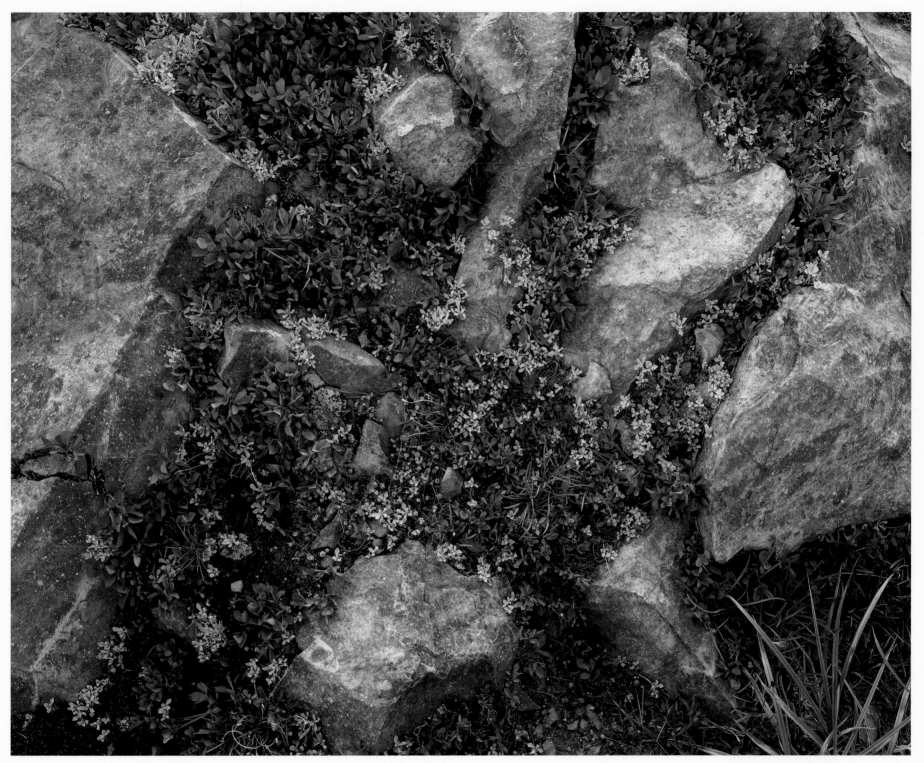

DETAIL, CLARK RANGE

basin, is a pool: a few tens of gallons of recent rain, evaporating already. When the wind stops, it is clear to invisibility.

I sit beside it in silence, gathering details.

From this point I can see most of the country I have traversed. It's not a region of great peaks and walls, but a gray, tilted table, intricately scored by ice and water. Streams wander through it on odd courses, with sudden turns and unexpected detours. Beyond the glaciated country rises the forested arch of Moraine Ridge. Nothing artificial, not even the line of a trail, cuts the pattern of coherent, inevitable forms.

Obeying a sudden urge, I bend over and scoop a handful of water. It is unsurprising. It is warmish, clean-tasting, with an after-redolence of pine.

I do not expect a sign, an insight. I have not been on a "vision quest." This landscape is not a vending machine, primed to dispense enlightenment to the odd pedestrian. It has its own business to attend to—the late-season, food-gathering, fat-building work of marmot and Clark's nutcracker and golden-mantled ground squirrel—the work of life on the line, as the cold comes on.

And yet, sprawled on my rough couch, I'm aware of a thought that has been trying to think itself in me for twenty miles. What I grasp, with a moment almost of vertigo, is just the ordinariness, the practicality, the concreteness of everything wild. This middling hump of granite, with its evanescent pool, on the edge of winter and the alpine zone: what is this but a fragment of the *normal* world—the world built by its own patient necessities, the world as most of it was before our human kind grew so much in numbers, arrogance, and power?

Suddenly it is not the wilderness that seems exotic, exceptional. It is the other realm, the one to which I will now reorient my steps. How baroque it is down there! How operatic! How extreme! What a swirl of luxury, power, genius, promise, misery, selfishness, and sheer appalling waste!

What I grasp is just the ordinariness, the practicality, the concreteness of everything wild.

Suddenly it is not the wilderness that seems exotic, exceptional. It is the other realm.

I am no hater of cities, no despiser of technology. With my fancy gear, not to mention my titanium knee, I can hardly afford to be. But that one species should have taken so much, transformed so much, occupied so much, strikes me today as utterly fantastic. How dare we so turn the tables on Nature that the ancient state of affairs is the exception, allowed to survive on a few small scraps of territory for which we have no other urgent use? Do we think it is permissible to use it all, to stake our greedy claim on every fragrant precinct of the planet? Who said we could?

Well, we said it to ourselves, of course: having the power.

But we also have the power to say other and gentler things, and we are trying to. The existence of a Yosemite National Park, despite its wounds, is evidence of that. Maybe our present parks and wilderness areas will appear, some centuries hence, like the Irish monasteries in which, during the dark bookless times, the old Roman learning was kept alive. The light of wildness has not gone out. Someday we will let it shine more widely.

Someday—from this vantage, I am sure of it—O'Shaughnessy Dam will come down, Hetch Hetchy will be restored. The thought has already been raised, to hoots of derision. That's the way these things begin.

It is time to set out on the long descent along Tilden Canyon, across lightning-menaced slopes near Avonelle Lake, down huge meadowy steps to Tiltill Valley, a kind of pocket Yosemite where I have been warned to expect aggressive robber-bears but will see only scat full of seeds. On to Rancheria Falls and the long spike-shape of the reservoir. Back to road, car, highway, valley, town.

I take my last picture, shrug on my pack (a feather now), and turn my face out toward the wide and damaged world.

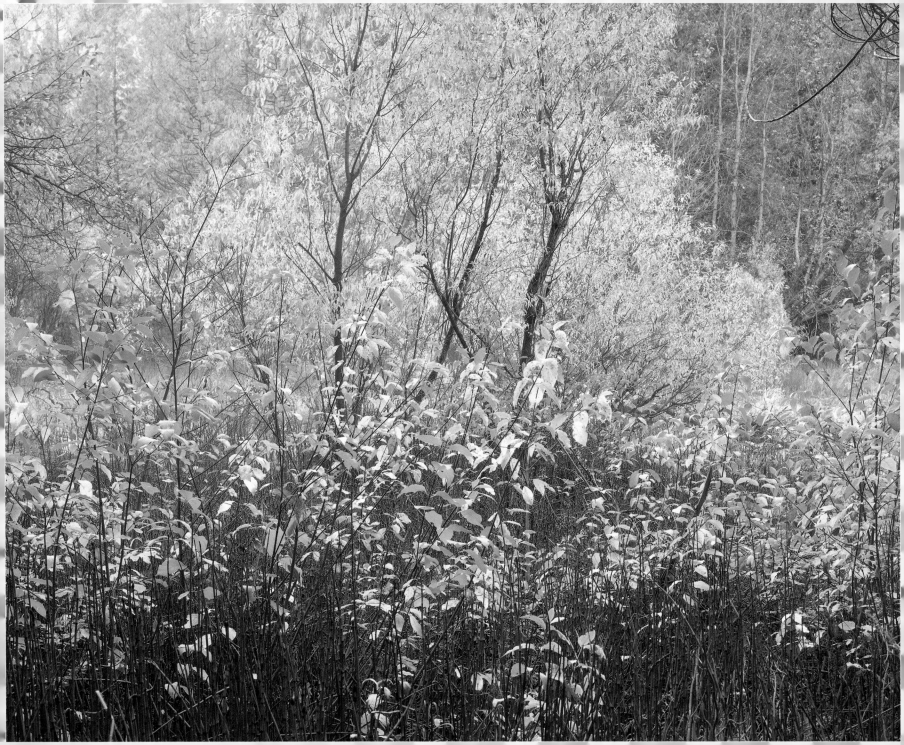

\mathscr{T}here is a blank spot on the Yosemite map that is mysterious partly because it is so visible, a secret wilderness hidden in plain sight, right at the edge of Yosemite Valley. Look up Tenaya Canyon from

The Canyon of Glistening Rocks

pavement's end at Mirror Lake. Millions do, every year. Many will stroll into the mouth of the canyon, the only breach in the otherwise box-canyon walls of the upper valley. But in a mile the broad trail turns, crosses Tenaya Creek, and scuttles back to the stables, forming a convenient loop for that packaged western adventure, the two-hour ride. Millions more look down into this canyon from above. Olmsted Point is the one obligatory stop on the Tioga Road through Yosemite's high country. Even the terminally hurried are dragged off the road here by the sheer breadth of the granite landscape.

BY DOUG ROBINSON

Eight thousand feet up, this is the High Sierra, where the sky seems a deeper blue from being framed in such an expanse of white granite. Half Dome looms, barely five miles away. Tenaya Canyon is right there at your feet, yet you can't quite see into it, hidden as it is over the first smooth roll of graceful granite.

It is late in the season, late in the twentieth century, and threatening rain. I am so "time poor"—as John Muir put it—"as to have but one day to spend in The Yosemite." So I drive right through the valley, where a controversy rages because the rangers have lost their senses and want to crowd highrises into a couple of acres of Swan Slab Meadow. That will block the sunrise from Sunnyside Campground, historic Camp 4. It's all because everyone has been obsessed with the river; last year a "hundred-year flood" washed away a lot of buildings. The park planners are determined to keep their boots dry, and this meadow is one of the few spots above the high-water line.

In the Ahwahnee parking lot, I pack peanuts, a light rope, and a rain parka, and head east. Under Half Dome, Tenaya Creek feeds into the Merced River. The river has dropped from Little Yosemite, where the bears are so acculturated that they have been known to wrestle backpackers for the refined food they carry. At the confluence I go the other way, following Tenaya Creek, seeking a place without history, a little respite from the clamor of the millennium crashing to a close.

The escape is gradual. The trail is paved, skirting a spot where the Ahwaneechee wore smooth holes in the bedrock grinding acorns. A young climber nods, bending under a slippery haul bag. Others are drawn to the banks of Tenaya Creek. An American couple leans together, while two Japanese have separated, squatting quietly by the burbling cascade. A raging extrovert accosts me: "You look happy. I tell people that I've been coming here for forty years." The Germans want to know how far is the

There is a blank spot on the Yosemite map that is mysterious partly because it is so visible.

parking lot, in kilometers. A young woman in a wheelchair looks up from the water with a radiant smile.

In the wake of the flood at Mirror Lake I step aside for a pack train carrying bags of cement. They have churned the trail into a urine-soaked quagmire while rebuilding it stout enough for horses. I tiptoe along its margin, ready to get beyond the reaches of so determined a civilization.

There are other Yosemites in the lives of men, and Tenaya Canyon is mine for this brief spell of an autumn afternoon. As the sound of the cement mixer fades, I find an abandoned trail, built in the same heroic mode as the one below, but with its cut-block causeways and riprapped inclines nearly hidden under fallen leaves. It leads me to the brink of Snow Creek, then vanishes. Beyond is a canyon too slickrock-rugged for trails, a place kept wild by water. I'm not a water person; I live in sight of the ocean and never go in. But set it to flowing over granite and I'll come clear across the state to spend the afternoon in its presence.

This drainage is not huge by Sierra standards, maybe only a tenth of the park. But it encompasses most of the skyline in that view from Olmsted Point, running up to the slopes of Mount Hoffmann and Cathedral Peak to form a catch basin that is largely smooth, solid granite. Even a little summer rain rolling off these polished flanks will magnify as it collects into Tenaya Creek. The gleaming granite is deceptively smooth, and often enough its surface has been further burnished by glaciers; the Yosemite natives called this trench "the canyon of glistening rocks."

I have broken out the rope at surprisingly low angles in this drainage, like by the slithering water below Cathedral Lake. And once, on Pywiack Dome, I misjudged the seriousness of an afternoon scramble enough to need a party of rangers with ropes to rescue me. To get into Tenaya Canyon you must dare to take it on its own terms; this journey is definitely not for everyone. Indeed, only the faintest trace of a path leads

103

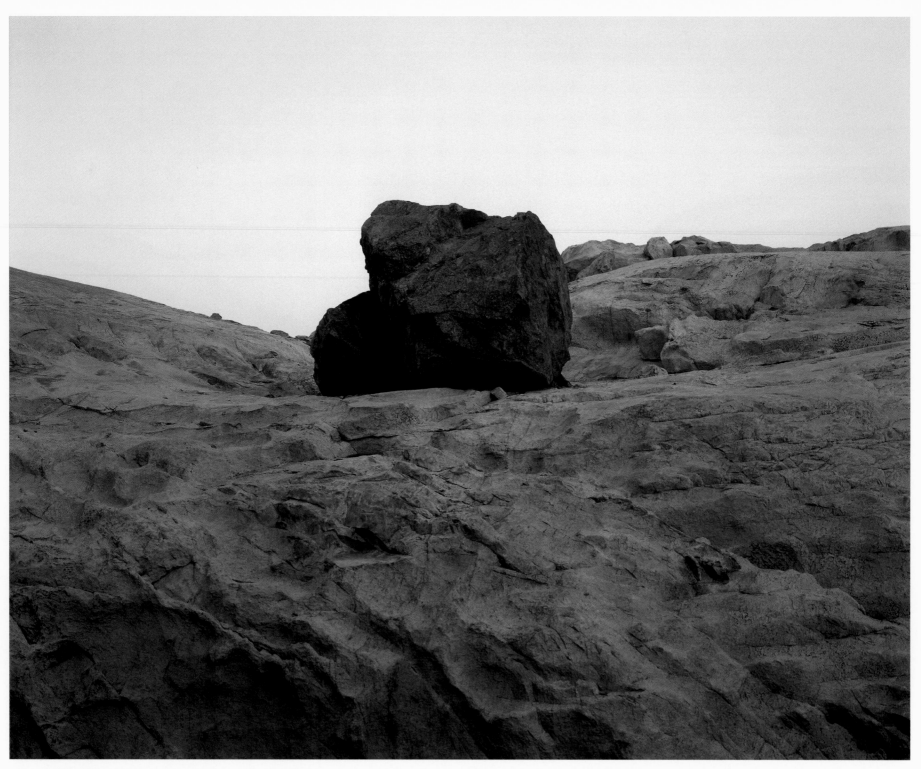

GLACIAL ERRATIC, CLARK RANGE

I can't even guess how many people

stop to feed the marmots

at Olmsted Point or picnic at

Mirror Lake. I do know that

very few of them realize

that a completely wild

Tenaya Canyon is just a step away.

C.F.

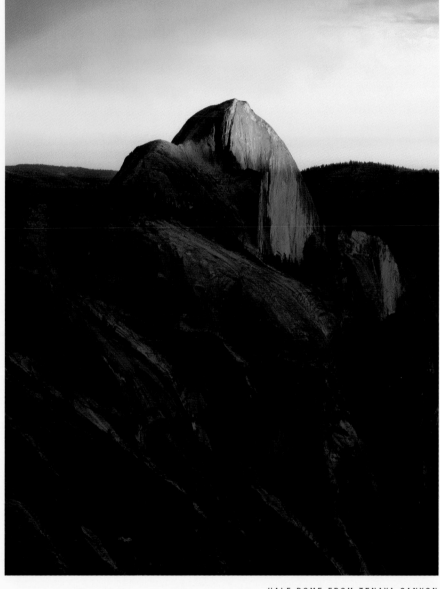

HALF DOME FROM TENAYA CANYON

The flood has ripped the terrain into a chaos of boulders and tree trunks.

onward. In spite of the cairn markers, I lose it repeatedly, give up, and decide to walk in the creek bed.

The flood has ripped this terrain into a chaos of boulders and tree trunks. Its margin is an abrupt earthen bank twenty feet high and so raw that its upper edge over-hangs, with roots dangling. Beyond, the forest floor is placidly the same as it ever was. Where the torrent has passed, a hundred yards wide—two hundred in places—pale boulders are strewn. The water-worn are thrown in with the just-unearthed. Some are fifteen feet high. Not a patch of lichen in half a mile; every rock has just been churned up from the subterranean.

This is not a pretty wilderness but an awesome one. My mind recoils slightly. It is work to step up to the power of chaos. It's one thing to embrace it as idea, another to accept the effort of meeting it. Moment by moment I hesitate, foot poised in the air, indecisive of inventing it a landing. An aluminum frying pan that has been mashed flat teeters conspicuously on a boulder. Someone has placed it there, like balancing a rock on a fence post, or a jar on a hill in Tennessee. It relieves the chaos a notch, forcing a smile of recognition.

This hundred-year flood is actually the second one in this decade. Two years in a row we've had them. I was here in Yosemite for another in—was it 1958? I was a boy, and the setup was eerily similar. By New Year's there were a few feet of snow in the high country. Then it turned warm, started to rain. The rain melted the snow and every-thing poured over the rim of the valley, seemingly at once. Water was everywhere. It crept up over the road below El Capitan and for three days we were sealed into Yosemite. I waded out to the arched stone bridge over Yosemite Creek, only its crown still above the flood, and looked up the valley at a square mile of water. Still it rained. The strangest part came that night: huge boulders washing over Upper Yosemite Fall crashed into bedrock with deep booms that reverberated through the valley.

\mathcal{W}hat might a thousand-year flood be like? At the California Water Department in Sacramento a rainfall profile of the last thousand years reveals a number of interesting things. Perhaps the most striking is that the thirty-year period from 1950 to 1980, when many of us grew up and calibrated our innate sense of weather, was the most even-tempered of the entire millennium. Further back, there are several thirty-year droughts. Also some very wet decades.

Don't pause too long to ponder this; it is late in the season. Another winter approaches. I have seen several years when 800 inches of snow fell, including the hundred-year flood. Yet none of them matches up to the winter of 1906-07 when seventy-three feet of Sierra snowfall were recorded near Lake Tahoe.

We love the extreme possibilities of climate; they form another, inescapable kind of wilderness that bears down upon us even in the bosom of civilization. There are more devotees of the Weather Channel than of Stephen King. I, among them, happily pay the cost of cable month after month for no other reason than to glimpse the swirling eddies of the global weather patterns, as they evolve in real time.

Weather is not the only wild thing that can—and someday will again—go bump in our night. Take earthquakes. San Francisco in 1906 is our benchmark, but the Sierra topped that in 1872. This young mountain range has reared up—slip-faulting and shaking—to most of its present height in only the last few million years. One March night in 1872 it bucked upward just another twenty feet, but that was enough to kill twenty-seven people in sparsely-populated Lone Pine, a settlement of adobe houses astride a fault below Mount Whitney. Survivors said that "the moon seemed to swing back and forth like a trainman's lantern. . .The roar was deafening." Modern estimates peg its strength at about 8.2.

The extreme possibilities of climate form another, inescapable kind of wilderness.

John Muir was sleeping in Yosemite Valley that night:

> *I ran out of my cabin, both glad and frightened, shouting "A noble earthquake! A noble earthquake!" feeling sure I was going to learn something. The shocks were so violent and varied, and succeeded one another so closely, that I had to balance myself carefully in walking as if on the deck of a ship among waves, and it seemed impossible that the high cliffs of the Valley could escape being shattered. . .Then, suddenly, out of the strange silence and strange motion there came a tremendous roar. The Eagle Rock on the south wall, about a half a mile up the Valley, gave way and I saw it falling in thousands of the great boulders I had so long been studying, pouring to the Valley floor in a free curve luminous from friction, making a terribly sublime spectacle—an arc of glowing, passionate fire, fifteen hundred feet span, as true in form and as serene in beauty as a rainbow in the midst of the stupendous, roaring rock-storm.*

Muir spent the rest of that night clambering over that newly-formed talus, still smelling of ozone. Afterward he began to notice the lichen growing on the surface of the older talus. Lichen grows at a measured and steady pace, so, like tree rings, it can show how long rock surfaces have been exposed. Comparing lichen all over the valley, Muir estimated that it was all about the same age—400 years. Which, of course, hinted at an even larger quake earlier in the millennium.

I hoist myself out of the fresh gully of the streambed and look with renewed interest at the rock piles between me and the smooth, bright walls. Lichen dots these cones of talus that punctuate the cliff faces and reach thousands of feet upward in places. They seem so permanent. But my sense of historical flux and geological cataclysm keeps expanding, straining my credulity. I can get my mind around this much hydraulic reshuffling of Tenaya Canyon, but. . .A sensibility calibrated on thirty years of fine

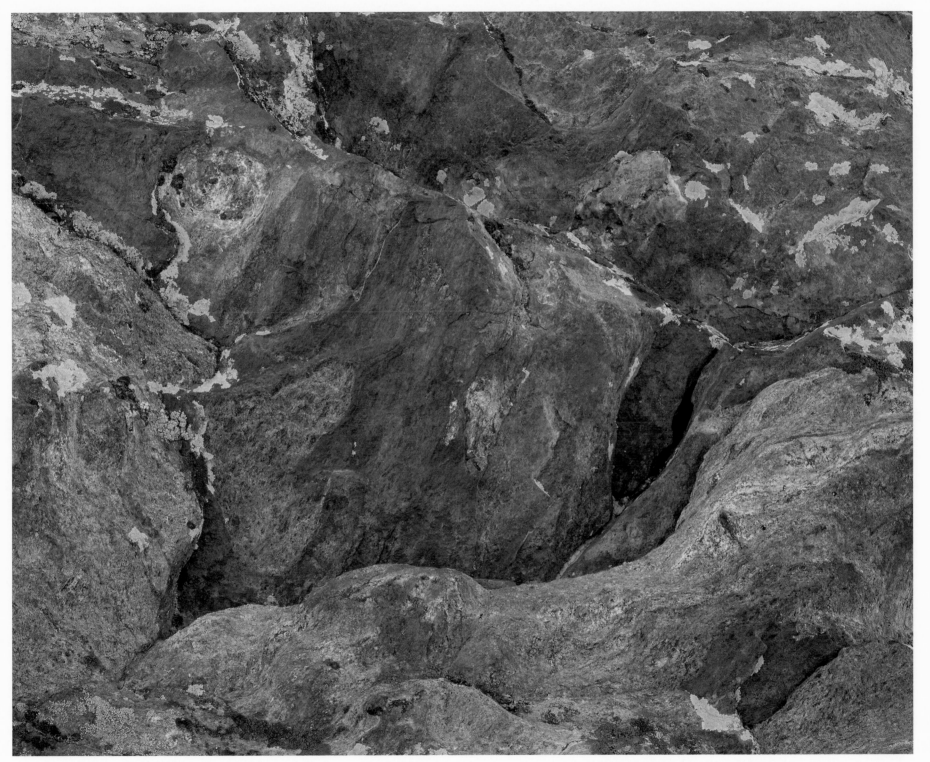

ROCK AND LICHENS, SPILLER LAKE

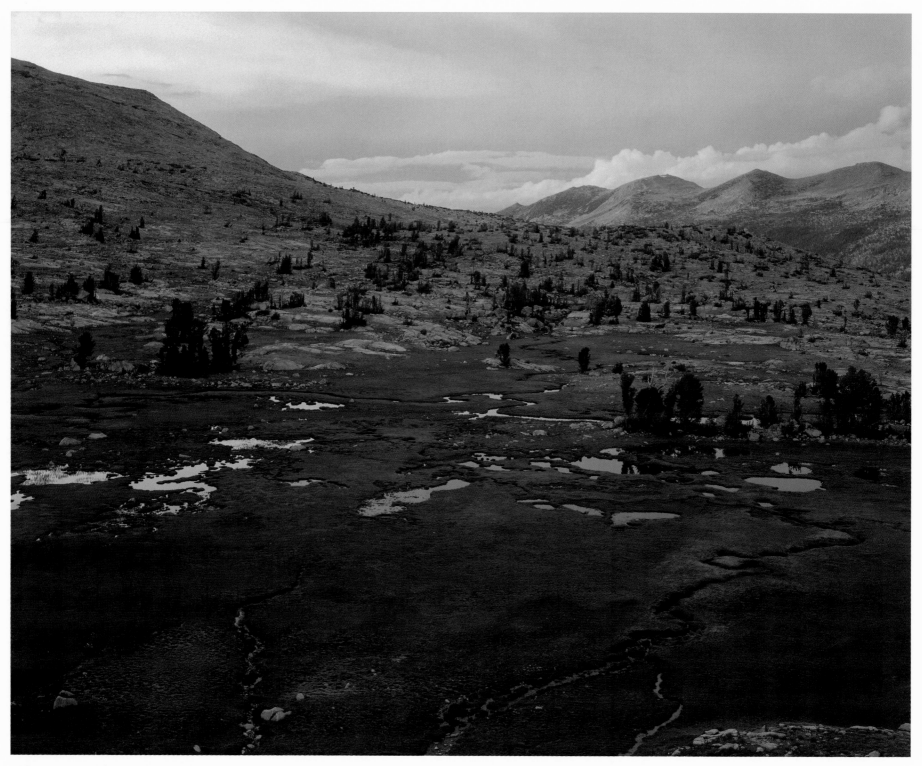

LOOKING NORTH FROM MACLURE CREEK

weather and half a dozen earthquakes in the Richter six to seven league begins to balk when the power scale waltzes from a hundred to a thousand times greater.

Another order of magnitude of destruction gets heaped on. The story I have just remembered is this: Seattle's earthquake horizon is placid—no historical quakes. But an Indian legend tells of a huge quake on a cold winter night, followed by a tsunami that wiped out coastal villages. Call it quaint until a Japanese earthquake researcher uncovers a seaport log of a six-foot tsunami arriving there at 9:00 p.m. on January 27, 1700. He eliminates all other Pacific Rim origins except a fault off the coast of Washington. Then tree-ring studies are done on a host of dead snags along the waterline of Puget Sound. The last annual ring is in 1699. Based on the height of the tsunami, the quake's intensity is calculated at nine, much larger than anything we know about in our thin record of history.

Abruptly, the raw terrain ends, reverting to a regularity of polished stream boulders. I look up, notice the walls again. Mount Watkins, which resembles El Capitan, shoots up one side; the two elegant Quarter Domes frame the other. Everything is so big that I grope unsuccessfully for scale. The bigger of the Quarter Domes has a glaring white scar on its face, maybe two hundred feet high, where a piece of exfoliating granite skin has sloughed off. Judging from the broken edges, the slab was only a couple of feet thick. I take photos, snack, and reach for a sweater. Then I glance down.

Shimmering is the surface of the pool, as bright as its basin of granite. Hypnotizing. The world implodes into that dancing light. Or the liquid surface rises up to engulf the world. Strange, that opposite descriptions equally apply. Time stops, then yawns and stretches to infinity. Oceans of contentment roll. Whatever remained of I belongs to this.

Everything is so big that I grope unsuccessfully for scale.

Thus the heart of the wilderness experience. You set out preoccupied—shoelaces, sweater, hide the car key. You travel: quads, heart, sweat. In this primal zone one integrates the calculus of time and distance only by effort and attention. Your senses are prepared. Then, gratuitously, things open.

Arise and hurry onward. The gates of the inner gorge are just above. Excitedly, I enter this narrow slot, deep enough to make its own twilight. I know from the literate old guidebook (the new one doesn't mention it) that this will be the crux of my passage. In times of high water one must climb up and go around, but I head straight on in and soon am balancing along the slippery waterline, fully engaged. Where are the landmarks? The big chockstone? The split boulder to walk through? Washed away?

A little delicate friction, pass a bolted rappel anchor, hop over a sluice of water. No, this won't work. Go back, try the other side. Traverse the vertical wall. Go high enough on the wall, above the usual high-water line, and the rock is rough with good holds. They work fine at first. Hand jam, stem a long step, then everything slopes me toward the water. Slip here and I pitch backward into the creek; if I land on my head, I drown. The self-reliance that wilderness requires is one of the reasons I come out here. I think of my family and of an unfinished book. I back down again. Standing by the old bolts, their hangers bent flat by the torrent, I look down canyon. A wispy cloud has settled over the top of Half Dome, and it is shot with the first color of sunset.

Scuttling back across the friction, I try to climb the north wall. Two, three places it is jumbled and overhanging. I turn and clatter down loose stones and scree to the creek bed, passing a baseball cap lodged in a bush proclaiming "Mono Lake is Worth Saving."

I turn downstream, content to come back another time to work this passage, to probe the mystery of the upper canyon. Above is Lost Valley, and further on Pywiack

The self-reliance that wilderness requires is one of the reasons I come out here.

It has taken most of the afternoon to take up residence again in my body.

Cascade, slithering down hundreds of feet of crackless slab. In between are the views I'd been seeking of Tenaya Canyon's biggest wall, the slabby undulating sweep of Clouds Rest. I will have to return to look straight up it to where the avalanches fall, like the huge one lubricated by water that I witnessed from skis on a spring day when I was the only person at Olmsted Point.

This late in the season, dusk arrives in a rush. Moving with easy instinct at last, I find much more of the faint trail even in the dark. When I lose it I crash happily through the poison oak. The light is gone. I take out the headlamp and mount it up, but I keep moving without it, preferring to sense dimly the outlines of the canyon around me than to sharply illuminate detail unanchored in any context.

It has taken most of the afternoon to take up residence again in my body and get the beast moving with any sense of grace. I think of some lines I wrote, panting toward haiku, last month on a Coast Range run that began in redwoods, then surged over rolling meadows down to the Pacific:

> *It ran by itself*
> *Then I ran for a while*
> *Then it ran again.*

The stench of horses welcomes me back to the main trail. But the clouds are breaking up, and half a moon shines through. North Dome and "the great South Dome" that we now call Half Dome snap into focus, sentinels over this re-entry into Yosemite Valley. Context returns. Just one afternoon in the wilderness has left me grounded and wide awake. At this rate I yet may be able to face the millennium, and even carve with some intention upon its unformed face. As long as I can do it on foot and one moonrise at a time.

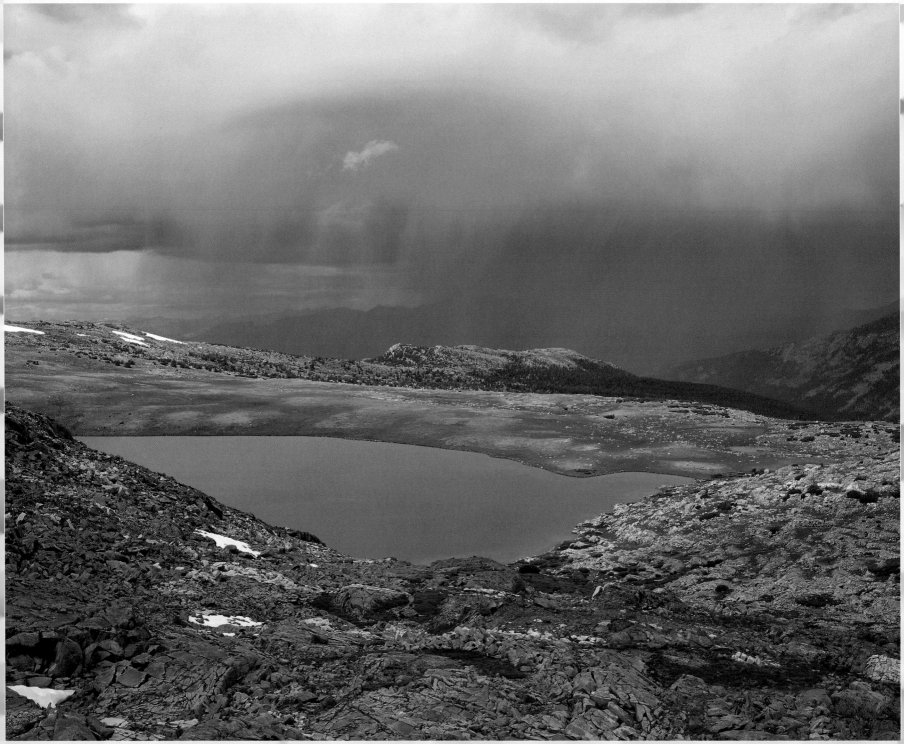

Photographer's Notes

BY CLAUDE FIDDLER

I took my first Yosemite photographs on family outings, and surviving snapshots show my sisters or grandmother posed at one or another of the park's famous vistas. My technical knowledge at the time was limited to the use of the camera's self-timer. Later, during high-school backpacks, climbs, and ski tours, I made photographic diaries that portray some of the happiest times of my youth.

Climbing, skiing, and the social scene surrounding these activities eventually turned into a way of life. But it was not long before I lost interest in taking photographs of friends doing a particularly hair-raising climb or skiing a radical chute. Rather, my interest was piqued by richly illuminated Sierra sunsets, fall foliage along a mountain creek, and the pattern of winter's long shadows across an open slope.

My first attempts to use photography as a means of self-expression followed, the beginning of a process in which I am still involved today, a process marked by both success and failure. Through keen study and plentiful practice, I have tried to understand the technical and æsthetic considerations associated with using a camera to make an expressive image.

Although I've been photographing in Yosemite for nineteen years, I have made fewer than a hundred compositions. These have been accomplished both on longer explorations in the backcountry as well as on short outings to places I have visited many times. Living only an hour's drive from Tioga Pass makes it relatively easy for me to travel a fair distance into the Yosemite wilderness in a matter of hours. It typically takes me many visits to a specific location—and much study of a composition—before I make a single exposure. Not many photographers are able to take the time necessary to do all this.

Aside from tramping through the High Sierra with my camera, there's nothing I look forward to more than spending a stormy winter day at home, pouring over topo maps and planning a summer trip. With practice, I have learned to envision possible compositions during these armchair explorations. Months later I hike in to a particular spot, deep in the backcountry, and, if all goes well, take a photograph that's been lurking in my head for months.

THUNDERSTORM OVER
IRELAND LAKE

For instance, I had wanted to visit the Marie Lakes for a long time. This intriguing collection of lakes lies south of Donohue Pass, and a concentrated stint of winter map reading led me to believe that excellent photographic opportunities might be had from this location. I was convinced I'd find both an interesting shot of Rodgers Peak and a commanding view of the Lyell Fork of the Merced from the ridge that separates Rodgers from Mount Lyell.

The hike from June Lake began in a drenching rain that didn't quit until after nightfall. The following morning was raw and windy, as September days in the Sierra can be. In the early afternoon I arrived at Marie Lakes, relieved to drop my eighty-five-pound pack, and quite excited to have a look at my pre-planned composition. After setting up camp I packed my camera gear, extra clothes, and a snack, and made my way to top of the 12,500-foot ridge between Lyell and Rodgers. The storm had ended, but five inches of snow lay at the higher elevations. I could kick steps up the icy slopes, but it was treacherous going through the white powder covering the loose talus.

When at last I reached the ridge crest, I could see a basin of partially frozen lakes a thousand feet below, curving away to the south and west like a winding staircase. Electra Peak and Mount Ansel Adams loomed darkly over this landscape, and fast-moving clouds dappled the scene with shadow and light. I composed one image and took three exposures. As I directed my attention to making a portrait of Rodgers Peak, things got interesting.

My tripod set-up was very difficult and dangerous because the ridge dropped vertically for several hundred feet below my camera. Because the tripod barely made contact with the snow-covered talus, I had to move gingerly around the camera as I worked. My concern was not only about bumbling the set-up, but also about making sure I didn't plummet off the ridge. I waited until every snow-covered ledge on the

north face of Rodgers was etched by the light into needlepoint sharpness. As the autumn day came to a close, I had time to make one promising exposure. The dark chill of night was upon me as I hightailed it back to camp, hopeful that the results would be good (page 20).

I wasn't always so fortunate, of course. On one recent afternoon the rain that had been drumming down on our tarp turned to wet, sloppy snow. Even though my friend Danny and I were quite comfortable, we would have preferred sunning ourselves nearby on the granite slabs of Smedberg Lake. It was less than perfect Sierra weather, and as a climber, skier, and wilderness traveler, I'd come to expect and enjoy day after day of cobalt blue skies. But as a photographer I have learned to appreciate and even hope for the changing light of Sierran storm cycles. It would have been simple to photograph Smedberg during a break in the storm, in outrageous sunset light, but I was after something different. I did not want this book to be filled with fifty sunset photos.

Somewhere in the Smedberg region, I felt sure, there would exist a perfect image of a middle-elevation lake, surrounded by granite slabs and stately lodgepole pines. I imagined afternoon light reaching through the lakeside forest and illuminating the granite cliffs plunging into such a lake. Alas, I never found this perfect spot, but the next day, in "ordinary" lighting, I made an image of Smedberg itself that came about as close to my imaginary lake photograph as I could have hoped (page 77).

To me, the Yosemite landscape has always seemed to be inhabited by Hobbits. Being out in the backcountry with my three-year-old daughter, Laurel, certainly helped heighten this impression, especially when her imagination ran to fairies, witches, and goblins. While taking the photographs for this book, I was continually delighted to find well-ordered gardens, musical streams, and hidden tarns throughout the park. It was enchanting to wander along the intricate shorelines of lakes, to watch the setting

sun change the color of the fabled Yosemite granite from cold gray to warm magenta to twilight blue, and to listen to a tumbling creek sing a perfect song.

On one trip to Virginia and Spiller Canyons, I found the high alpine plateau dividing the canyons a perfect place to picture my daughter's imaginary world. Dwarf junipers and tiny alpine flowers hugged the ground, and while changing film high on this plateau, I found an arrowhead. It occurred to me that the carver of the point surely must have been there to take in the view.

On the last day of our trip I hiked for the third time to a remarkable scene I had found as we had wandered aimlessly among the alpine gardens. I took my photograph (page 113) as the frame of the composition moved into shadow. Lingering on the plateau afterward, I watched a golden eagle soar over the darkening depths of Virginia Canyon, its wings catching the warm colors of the setting sun. As I shrugged into my pack, I realized that my daughter's world wasn't so imaginary after all.

The photographs in this book are meant to illustrate what exists beyond the roads and beaten paths of Yosemite. I could have taken these photographs in a few months rather than a few years, but I am not satisfied with compositions that are not well thought out. I want my photographs, as my friend Joe Holmes so perfectly puts it, to be 100% complete, with every element a part of my intent. By this I mean that the photo, by my design, is perfectly balanced and contains detail, complex shape relationships, color, movement, and exquisite light. Because I've set a near-impossible standard, only a few of the photographs in this book meet all the above criteria.

While all of the images included here constitute a body of work connected by a theme, it will continue to progress and evolve. There are a number of places and photographs that I would like to have included. There are many places I went where

the light did not cooperate, or a storm kept me moving, or I just did not see anything worth photographing. That's okay: Yosemite and I aren't getting tired of each other.

A few technical matters. I use a 4 x 5 Gowland field view camera exclusively. I helped design this camera for rigorous backcountry travel. For a tripod, I use a Gitzo "Reporter," the lightest tripod Gitzo makes, with an extremely smooth and stable Arca Swiss "B1" ballhead. To add stability, I usually attach my backpack to the extended tripod center post and pile rocks onto my pack as ballast against wind or tripod movement.

I use three lenses, a Rodenstock 150mm (my favorite), a Caltar 210mm, and a Nikon 300mm. These lenses are slow, and a one-second exposure is a gift; more often than not my exposures are several seconds long. The longest for this book was a minute and forty-five seconds; the shortest was an eighth of a second. I usually work between f-stops 16 and 32. Each lens is fitted with a Tiffen step-up ring, a Hoya UV0 filter, and a Tiffen 81B filter to correct film response to high-altitude light.

All of the photographs in this book were made using the Fuji family of films: Velvia, Provia, and Astia transparency films, and NPS negative film. The majority of photographs were made on Astia.

I also carry a Camera Essentials film changing tent, a Pentax calibrated spot meter, film holders, a magnifying loupe, and various repair items. The entire camera package, along with some food, water, and extra clothes, always seems to fill my Gregory "Denali" (the largest pack Gregory makes) to near capacity.

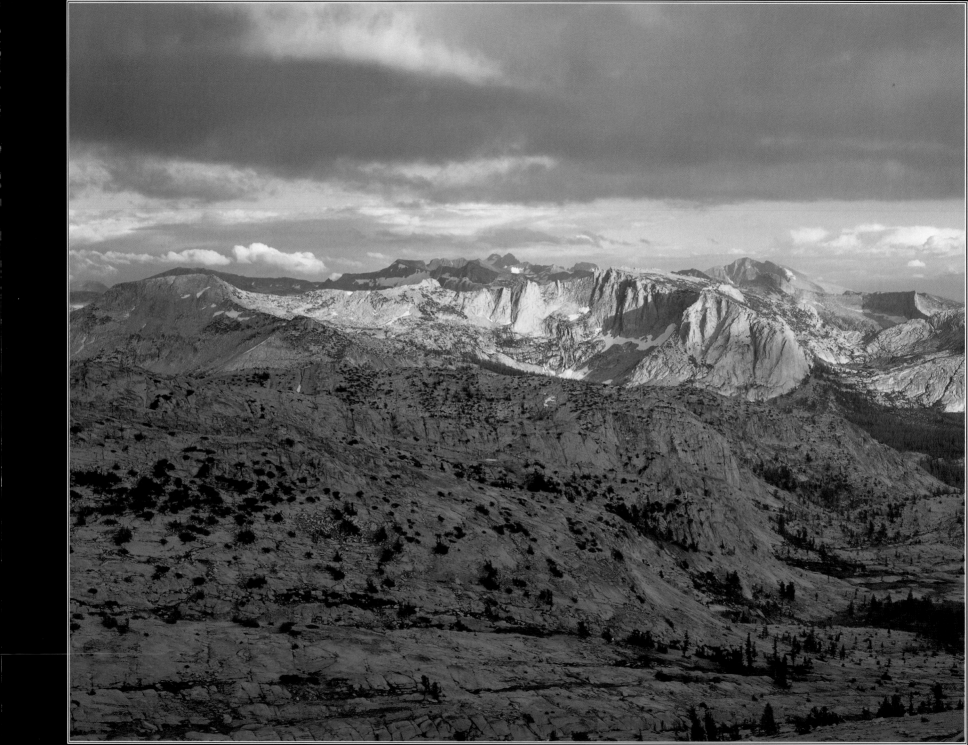

Acknowledgments

It is impossible to separate my photography from my life. It is what I do. So I'd like to start way back, thanking first my grandmother Ruthie for my childhood trips to Yosemite, and then my parents David and Maria Fiddler, who dropped me off in later years for my first climbing adventures in the valley. They gave me freedom—and I have to commend their parental courage! I spent a decade of summers climbing in Tuolumne Meadows, and I want to thank all the characters from that time in my life for the great memories. Those were the days!

During my evolution as a photographer, I have asked for, and received, a great deal of generous advice and assistance. I am honored that Joseph Holmes has written the foreword to this book. Joe, an exceptionally fine artist and a good friend, has provided me with years of technical and aesthetic advice and has, on occasion, delivered crucial kicks in my photographic butt. John Wawrzonek and Mark Doyle also have been generous advisors. Steve Solinsky has been an inspiration for me over the years. My thanks to a host of other people—John and Dorothy Ingersoll, John Dittli, Bruce Horn, Galen Rowell, Robin Ingraham, Jr., Ron Kirchoff, Bob Pace, J.T. Ravize, Rob Sheppard, Jim Stimson, Michael Wilder, Andy Selters, Bob Jones—for being there along the way.

Steve Roper, who wrote the introduction and monitored the other text for this book, is one of the most conscientious persons I have ever worked with. We have collaborated on three books, with more to come, and I greatly value his expertise and our friendship. The essayists for the book—Nancy Fiddler, Anne Macquarie, John Hart, and Doug Robinson—are talented individuals, and I am grateful that this quartet of Yosemite aficionados took the time to make this book an extra-special one. Nancy extends her thanks to Cathy Rose, our local botanist and grammarian, who graciously helped with her essay. A big thank you to Steve Medley and the Yosemite Association for taking on this project and Lee Carlman Riddell for the book design. Our long distance relationship has been a good one.

Good companions in the mountains are hard to come by, but I have had a lot of fun in the hills with Michael Cohen, Valerie Cohen, Bob McGavren, Danny Whitmore, my wife Nancy, and our daughter, Laurel.

CATHEDRAL RANGE
FROM MATTHES CREST

Film, processing, equipment, gas, food, and the occasional blown transmission fill the expense column until the cost of making a photograph becomes an expensive endeavor. I am indebted to the following individuals and companies for their generous sponsorship of this project.

Dion Goldsworthy of Gregory Mountain Products provided me with two packs, a "Denali Pro" and a "Day and a Half" (my first Gregory pack lasted fifteen years). I carried both packs on all of my longer trips, attaching the "Day and a Half" to the outside of the "Denali." View-camera gear is heavy and bulky, and I quickly learned the importance of a roomy and comfortable pack when I traveled with Nancy and Laurel. Nancy would carry Laurel while I carried some of the load. After reaching camp I would return to pick up the rest of our gear. Each load weighed between seventy and eighty pounds.

Paul McKenzie of Clif Bar provided us with the only food that Laurel seemed to eat in the backcountry. Clif Bars have gotten us through many long days in the mountains.

I thank the Rossignol ski company for the ski equipment for my winter excursion into the park. Although I have included only one winter photo (it was the only one I made), I have used Rossignols since 1973 on many trips into the winter wilderness of Yosemite.

A good exposure is only as good as the film it's made on. Tom Curley and Phillip Abel of Fuji Film U.S.A. provided me with the film for this project. I have tested many films, finding that the Fuji family of films continues to yield the finest results.

Matt Hesketh and Rich Taylor, at Photomation, provided a host of lab services, from basic film processing to CD-ROM archiving and duplicating transparencies. Lots of labs do the same things Photomation does, but the quality and service are superlative at Photomation.

Martin Vogt of Arca Swiss provided me with an Arca Swiss "B1" ballhead. The secure attachment of my camera to the tripod is absolutely essential, and I found the B1 to be a perfectly designed piece of equipment.

With help from one special individual and one entity, I was able to complete this project. With past projects I have had to meet most of my expenses out of pocket. This necessitated an intense schedule of construction work to pay the bills—and frantic trips to accomplish my work.

My longstanding friend Bill Shupper made a crucial financial commitment to the project, and I am extremely grateful for his contribution. Bill works with and contributes to many charitable organizations, never with fanfare. In his words, "it's just what you do." Thanks so much, Bill.

Finally, the Mammoth Lakes Foundation, in Mammoth Lakes, California, is an organization dedicated to bringing higher education and cultural enrichment to the citizens of the east side of the Sierra Nevada. The board of directors of the foundation agreed to provide major funding for this project. Barbi Reed, Bill Shupper, J.T. Ravize, and the foundation staff were instrumental in convincing the foundation board that this would be a worthwhile sponsorship. I am deeply grateful to everyone at the foundation for the funding, and I hope that this book and the exhibit associated with it help them reach their admirable goals. CLAUDE FIDDLER